Friends and Friends of Friends

Bernard Pierre Wolff

Friends and

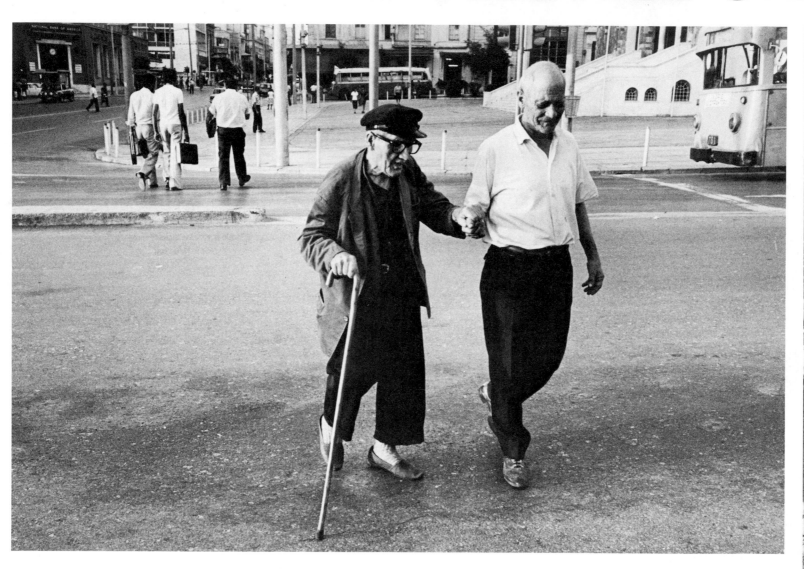

A Dutton Paperback **E. P. DUTTON** / **NEW YORK**

Friends of Friends

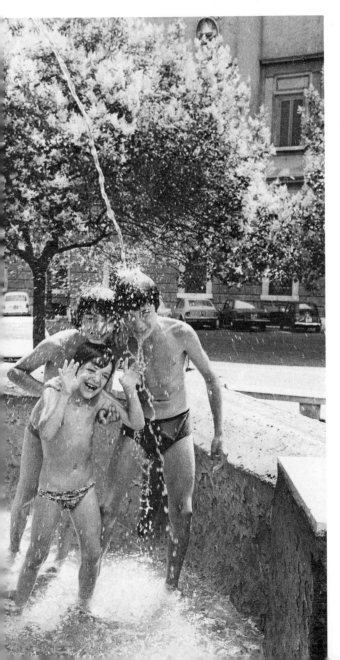

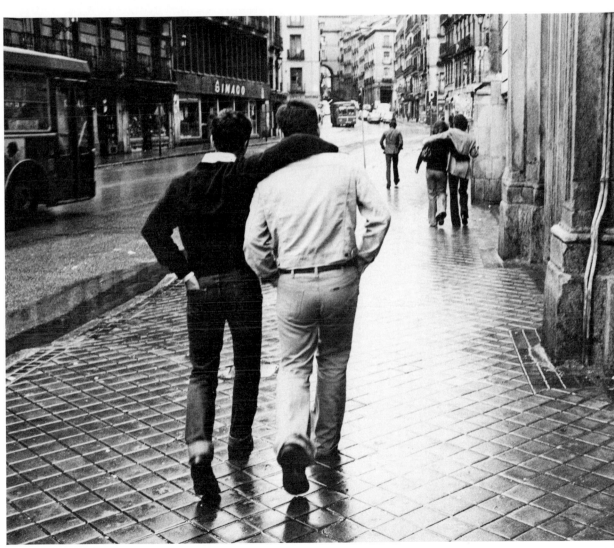

With an Introduction by John Leonard

To the memory of my grandfather, a great friend

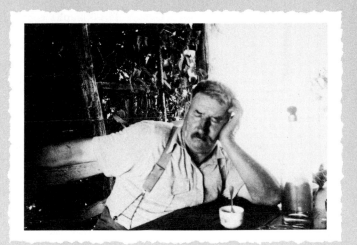

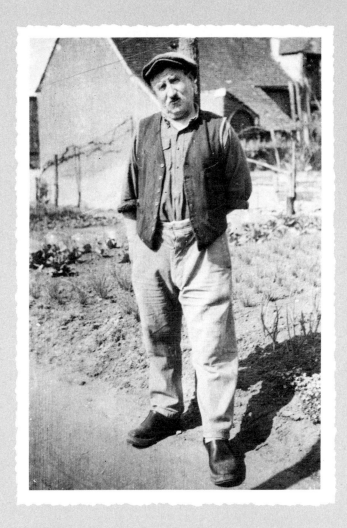

There are many friends who have encouraged me over the years.
My special thanks to:

Robert Adler
Leo Andrews
Yves et Jacqueline Delorme
Xavier Fourcade
Gerard Fournerie
Charles Harbutt
Helga
Dean Hoffman
Norman and Francoise Jacobs
Jane Jacqz
Lionel Landry
Joan Liftin
Jean G. Loth
Miriam Miller
Michael and Barrie Pribyl
Thetis Reavis
Julia Scully
Larry Siegel
Jeanne Singer
and Bill Whitehead, my editor

A new friend enriches our spirit, not so much by what he gives us of himself, as by what he causes us to discover in our own selves, something which, if we had never known him, would have laid in us undeveloped.

MIGUEL DE UNAMUNO

INTRODUCTION

I

You may take sarza to open the liver; steel to open the spleen; flowers of sulphur for the lungs; castoreum for the brain; but no receipt openeth the heart but a true friend, to whom you may impart griefs, joys, fears, hopes, suspicions, counsels and whatsoever lieth upon the heart to oppress it, in a kind of civil shrift or confession.
FRANCIS BACON

What men have given the name of friendship to is nothing but an alliance, a reciprocal accommodation of interests, an exchange of good offices; in fact, it is nothing but a system of traffic, in which self-love always proposes to itself some advantage.
LA ROCHEFOUCAULD

It happened twice in three months. I am sitting where I always sit, in a cubbyhole at the front of the house, over my toy typewriter, cranking out the psychic yard goods. There is a banging on the door around noontime; it is necessary to bang on my door because the bell doesn't work, and I am too busy typing to get it fixed. On the stoop is an old friend. In one case, the old friend is a novelist; in the other case, he is a scientist. In both cases, we go upstairs to the kitchen, because the women in our lives have taught us that serious talk belongs in kitchens. I am pleased with my kitchen. With its brick wall, its round oak table, the sunlight, the pepper mill, the wine glass and the black cat, it looks like a bad Impressionist painting. I grind beans for the coffee.

I have done them an injury, and they have each written me a letter. I won't specify the nature of the injury. The injuries I do are usually those of omission. That is, I fall periodically into an absorption with work so blinkered and dreamy that I forget to return telephone calls; I excuse myself from promises and appointments; I don't listen; I miss, at dinner parties, signals of distress that would have been obvious to a blockhead; I am away on a sabbatical. Other people tend, then, to try to figure out for themselves why I am behaving so badly. What have they done to deserve such indifference? In the fiction of our time, and in the lives of most of my friends, paranoia is second only to adultery as a preoccupation, and paranoia is gaining.

It is embarrassing to stand in your own kitchen, reading a letter of complaint from an old friend who has grimly imagined the causes of your disaffection—imaginings you know to be paranoid non-sense—while the old friend sits at your oak table, equally embarrassed, staring into his coffee cup.

What am I to respond? There is a French proverb: "Life is an onion and one peels it crying."

To which he may reply with a Spanish proverb: "If I die, I forgive you; if I recover, we shall see."

It takes a long time to grow an old friend. According to an English proverb, "You may poke a man's fire after you've known him for seven years." We have poked each other's fires. I babble my extenuations. He nods. If, as someone said, "friendship is like two clocks keeping time," then we have been out of synch; our needs haven't coincided; we have been listening to different music; perhaps I've heard no music at all. We will suture the wound with words.

How remarkable, really, that my two old friends should have bothered to write letters and to deliver them by hand. High noon in the kitchen. A woman would have called on the phone: I feel blue, and/or neglected; come over, or invite me out, or make jokes. These days, when women experience the discrepancies—the abyss between what is and what ought to be—they say so out loud, immediately, and what are friends for if not to babysit or apologize, to forgive or lead the cheering, during an attack of the discrepancies? Besides, I probably would have noticed, in the face of a female friend, a sense of injury or need. Women often talk with their faces; perhaps it comes from being stared at. Whereas we men usually hide behind our faces; what we think is nobody's business.

And men usually sulk, rather than write letters and show up on doorsteps. To admit that our feelings are hurt is to give away an edge; we walk through the valley of the discrepancies with an abstraction, like a sword, strapped to our side. What, me worry? Honor is one of those abstractions, and bravery. "The trouble with this country," the poet John Berryman once explained to the poet James Dickey, "is that a man can live his entire life without knowing whether or not he is a coward." It seems to me that this is a peculiar thing to worry about, but it is worried about all the time, causing trouble between men and women because women have to hear at length from men on the subject of our secret fears. To talk to other men about cowardice is unthinkable.

Tarzan comes home on the commuter train from a hard day at the office and demands that Jane fix him a pitcher of martinis. He downs four martinis without saying a word. "Tarzan," says a worried Jane, "what's the matter? What happened?" "Jane," says Tarzan at last, "it's a jungle out there."

That my two friends take our friendship seriously enough to write letters about it, instead of sulking, means of course that they take me seriously, too. I should be, and am, grateful. "May it

please God," said Thomas Fuller, "not to make our friends so happy as to forget us!" I should point out, however, that these two particular friends are specialists in not sulking. The novelist has made a career of dilating on the discrepancies. The scientist is a child psychologist. All over town, nonspecialists are probably sulking. I've been known to sulk myself, when the shoes of the mind are too tight.

But what had we talked about on previous occasions, before they came to my kitchen, while their injuries were festering unspoken? I remember talking about the usual things: baseball, Bert Lance, our jobs, the weather. I wonder if sports, politics, work and the weather—not to mention war and sex—were invented to give men something to talk about besides our feelings. I wonder if the infantry trench, the locker room, the box seat, the stock exchange and the saloon—where all the talk is of various kinds of scoring—were devised as safe houses, sanctuaries, demilitarized zones, a kind of neutral Switzerland. In an exchange of opinions on, say, a television program, nobody loses. What a relief.

In a book last year called <u>About Men,</u> the psychologist Phyllis Chesler identified our problem roughly along these lines: Sons long for the love and protection of their fathers, and usually don't get it. Fathers are off fighting with other men, at work and war. Sons will grow up punishing the women in their lives for what their fathers failed to give them and for the frustrations of their own work. "I see," says Dr. Chesler, "the terrifying battle between Fathers and Sons—which most Sons have always lost—confirmed; I see how every day Eve is punished again for man's anguish over Paradise Lost—and for her childbearing abilities."

She goes on: "Male emotions of rage, outrage, jealousy and shame—toward more powerful men—are laid to rest, or acted out, in women's beds, or in pornographic sexual fantasies. Pacifying sexual orgasms help men avoid the even greater excesses—of fratricide or patricide—that would otherwise surely occur in the 'dark Satanic mills' of male employment or on the male battlefields of war."

Some of this is silly: I go to bed with my wife for other reasons, and with quite different emotions. And some of it is sheer rant: "Men," we are told, "believe that women are not human beings." (I am reminded of similar rant, some years ago, from Shulamith Firestone, who declared: <u>"Men can't love."</u> It is, perhaps, undignified, to reply to such assertions: Who says? Or: <u>Wrong.</u> Nevertheless, they are wrong.)

But some of what Dr. Chesler says does seem to me to suggest a partial truth about our reticent and evasive ways in friendship with other men, our impacted emotions, our desire for some sort of hierarchial order. It is not, somehow, <u>all right</u> for us to be sad in front of other men. And it is only permissible to be ecstatic in moments of excess, when the rules are suspended: survival under fire, winning the game, a drunken binge. Then we are allowed to touch one another and to shout.

I do not believe (although I have no proof; I can only consult my own compass) that this wariness in our relations derives from some basilisk in the subconscious, flicking its tongue at the idea of homoeroticism; that we are, generally, afraid to acknowledge (or afraid to be interpreted as harboring) certain tendencies. Such a question seems to me to be as peculiar, and as irrelevant, as whether or not we will ever know if we are cowards. Emotional honesty is not the monopoly of any given group of subscribers to any given sexual preference. Looking over this portfolio of Bernard Wolff's wonderful photographs, in fact, I'm struck by how studied and unpersuasive are the poses of the men who have a specifically homoerotic point to prove. Theirs is a camerawise performance, a combination of sneer and smirk. They lack the spontaneity to be found in the photographs of the children, of the fathers and sons, of the grandfathers and sons, of the old men, even of the bums—the unguardedness, the self forgotten instead of the self as sandwichboard or advertisement. The genius of Mr. Wolff's camera, I think, is in its having caught us so often unawares, or so caught up in gusts of emotion (or so surprisingly languid, found rather than orchestrated) that we are honest. The art is not on our side of the camera.

When I am overcome by the ordinary discrepancies, I seek the comfort and advice of a female friend, who will at the very least tell me what not to do. When I am devasted—on the breaking up, for example, of a marriage—I call a male friend, who is appalled and silent. He doesn't know what to think; he listens and nods; his forgiveness is a blank check, but he doesn't want to leak any of his own pain for fear of seeming less than manly. And then, of course, when he cracks up, I behave in the same way. We want to be friends without talking about it. How odd: I am supposed, in my own distress, to tell my friend what to do about me. (And he will do it: marching orders, he under-stands.) And when he is in despair, I will be his secretary, but not his father. Our male friends must be much older, or much younger, before we will dare to be innocent, or wise.

What happens in my kitchen is an exception.

II

Life without a friend; death without a witness.
GEORGE HERBERT

Friends are thieves of time.
LATIN PROVERB

When my daughter was ten years old, she explained: "You don't need lots of friends. You just need one. But if you don't have one, life is hell."

Yes. Until a couple of years ago, my son didn't have that one, and it was bootless of his father to suggest that the situation wasn't permanent, ordained. He runs now with a pack; its members, improbably, are Latin scholars, given to bilingual puns. Should I have been his friend? My own father disappeared when I was eight, not bothering to leave behind much information on how to be a friend or a father. It was necessary for me to improvise. I wanted, naturally, to be perfect. I was, alas, not. The purpose of a peer group is to substitute for imperfect fathers.

If high school is rough, college is easy. In college, you have to live together, eat together, think together. You are possessed by an idea of the future. Unfinished, you can afford to make mistakes. Ambitious, you are free to postpone reckonings. You lie about your sex life and play poker or bridge. If you are unlucky, you will never experience again quite this intensity of comradeship and will spend the rest of your life waiting for these old friends to come to town and explain the mismanagement of their careers and their marriages. Since you, as a friend, predate those careers and marriages, your loyalty is undivided and your sympathy abstract, a form of nostalgia. You will vouchsafe your own failings, assured of a similar forgiveness. You will not, however, be permitted by the logic of this friendship to mention a success. That would be bragging, and competitive; it would pertain to <u>now</u>, and adulthood. You will, instead, be cynical about whatever it is you do, and try to pay for everything with a credit card.

I've been lucky enough to have stumbled upon several experiences of comradeship as intense as college was—at a radio station and at a newspaper—just when I had concluded that I'd lost the trick of making friends, that I was too old and too busy to be pardoned yet another time for my sins against intelligence and decency. It is amazing, when you are twenty-five or forty, to find yourself

among male strangers with enthusiams and prejudices identical to your own; to have your social and professional lives elide, merge, complement each other; to trade disappointments and "midlife crises" and "passages" and crack-ups and season's tickets to the Knicks. If I die, and I don't intend to, I will be mourned by a few men I met after I started losing my hair. I won't have rotted for long in my cubbyhole because they would have called nine times to propose a lunch and begun to suspect the worst.

My friends have funerals now—a cardiac is arrested, a lung is malignant—at which I am stupid. It is no longer possible to write them letters, to be embarrassed in their kitchens.

Yes, friends are thieves of time. When they aren't ticking along with my clock, I have found their neediness greedy, their sulks an imposition, their discrepancies mere funk, their letters an importunate nag. Why can't we go to a movie or a restaurant or the beach, instead of imparting "griefs…suspicions…and whatsoever lieth upon the heart to oppress it"? Whatever happened to brunch or Frisbee? Except, of course, when the existential funk is mine? Where are the telegrams of joy? I would, nevertheless, die for my friends if they called me on the phone and I didn't have a deadline. I have gone so far as to lend money.

And yes, "self-love always proposes to itself some advantage" in the "system of traffic" of egos, although I wonder whether La Rochefoucauld liked himself enough to sustain a friendship with anything but aphorisms. What in France is an "accommodation" is in Buddhism a virtue: reciprocity. Those male friends of mine who have expected "an exchange of good offices" on any level other than the spiritual ought to subscribe to another magazine; I can't help them—although, of course, I wouldn't admit this, any more than I would weep when feeling, in their presence, discrepant.

Still: I tend not to admit that I love someone if he is male, until after he can't hear me. This is a cold witness.

III

Friendship always benefits; love sometimes injures.
SENECA

The bird a nest, the spider a web, man friendship.
WILLIAM BLAKE

Maybe. Our hangover is the Greeks, who never got around to specifying the homoerotic component in their catharsis; and the nineteenth century, which protested too much about friendship without sex. In between Socrates and Tennyson-Shelley-Keats were an occasional Damon for your Pythias, a chanson of Roland, a Milton stuck on Lycidas, various flunkies for such as Dr. Johnson and Johann Wolfgang von Goethe, the Russians and iambic pentameter by Shakespeare. What I mean to say is that there was male friendship in Western literature before Gore Vidal.

In American literature, most notably, we had Natty Bumppo and Chingachgook, Ishmael and Queequeg, Tom Sawyer and Huckleberry Finn, Henry James and Henry James. Nothing happened. But after the ambulance corps of American writers went off to feel bad about World War I, male friends were—as if by some committee resolution—abolished in our fiction. In a clean, well-lighted space, they were not to be found, unless they were fishing or boxing or bull-running or feeling suicidal and not bothering to call or on the couch and ambivalent.

I believe this to be important, this heroic solipsism. First, we get rid of the children, because the children who never asked to be born threaten the fathers who are trapped and unfriendly. On children, who is there among our male novelists to speak? Updike on occasion, Bellow at a chilly distance, Vonnegut a flirt, Mailer and Malamud and Roth not at all. Henry James may be excused. Hemingway—with the exception of his last, posthumously published and sadly inadequate novel—avoided being a father and a son. Like Fitzgerald, he was his own bright little boy to the end, with room in the nursery for just one of us, and just one of our wooden swords. Faulkner violently engaged the generations, but his children were flowering curses, clocks wired to bombs; they proved a thesis. The male American novelist has been too busy in our time killing his father to contemplate being a father.

We have two recent exceptions: John Cheever in <u>Bullet Park</u> and Joseph Heller in <u>Something Happened.</u> In both novels, American fathers can't protect the sons they desperately love. They don't explain <u>why</u> they love their sons—the photographs of Mr. Wolff are more coherent on this point—but they agonize. Their awkwardness is incapacitating. They don't know how to behave, as if the novel were an embarrassing kitchen. Our culture has, by Spock and psychotherapy and the fiction of feminists, explained the way we are supposed to feel and act. They are inadequate.

After such fathers, what sons? How to love, or write letters? All the blame can't be piled on mother. Norman Mailer's mother, for instance, not only loves him but delivers his copy to magazines on the morning of the day that it is due, and says to the editor: "I hope you like it." But Mr. Mailer is somewhere else, feinting with the left, typing, grinding beans or getting married again to sire more sons he won't write about because writing about sons isn't brave—any more than delivering their copy or squeezing their oranges is brave.

If we don't know how to be fathers, and were never permitted to consider ourselves adequate sons, how are we to be expected to be friends with other men? Or women? If our fiction—like the situation comedy on our television sets—proposes stupidity as our condition and pratfall as our habit, where is honor? No wonder we are silent, or fail to return telephone calls, or are embarrassed by letters in the kitchen. How astonishing that Bernard Wolff should have captured us smiling, proud, in love, capable of sacrifice, being fathers and grandfathers with a particle of equanimity, growing old without a dazed surprise, still caring, pleased and at a loss, capable of tears and winks, spontaneous, nursing, ironic but not cheap, young. Oh.

When I am not talking in my kitchen to injured friends, or going to bed with my wife for ulterior motives that do not include an anguish about the paradise of Father Lost, I read novels for a living, after which I opinionize. On the whole, I prefer Mr. Wolff's photographs.

What seems to be the purpose of the modern novel? To demonstrate that language is inadequate.

How do we "sense" life? As tragic.

Describe your feelings about sex and history? Bad.

Once upon a time, in Ulysses, Stephen Daedalus and Leopold Bloom reached an accommodation, which was friendly. Later on, in Saul Bellow's Humboldt's Gift, Charlie Citrine and Von Humboldt Fleisher did not reach an accommodation, which was ambivalent. Otherwise, friends have disappeared from the fiction of John Cheever, John Updike, John Gardner, Jerzy Kosinski, Joseph Heller, Norman Mailer, Philip Roth, Walker Percy, you name him.

The people in the novels by Proust and Mann had friends, male friends, as if to make up for the fact that Kafka, unfortunately, wasn't even his own friend. But modernism—the suspicion that someone, somewhere, may give a damn—insists on alienation: no coffee beans. A friend would impede one's plunge into the abyss. A friend would interrupt one's theorizing about pain and anguish— one's wrapping of one's dead mice in rice paper and one's mailing of them to Dr. Chesler or Shulamith Firestone—with a telephone call. A friend would remind one of luck, and irony, and consolation, and generosity, and stamina, and debts. A friend would lead one to caves and lagoons in the valley of the discrepancies, where one could hide one's face. A friend would save one from the steely determinisms of Marx and Freud, with a letter or a kiss.

We have, apparently, to be surprised in our affection by an eye that wants to see it, so cunning are we at disguise. The modern novel is an orchestration; love and death go somehow unwitnessed. Bernard, fortunately, lurked.

Not having spent enough time in the kitchen, I have been writing and reviewing the wrong kind of novel.

IV

For, in certain moods, no man can weigh this world without throwing in something, somehow like Original Sin, to strike the uneven balance…this black conceit pervades him through and through.
HERMAN MELVILLE ON NATHANIEL HAWTHORNE

Why must we be surprised at love, and obliged to admit it? Men pant, and tire, and complain. Mr. Wolff specializes in the avuncular grimace. He would have been in my kitchen snapping a shot: my face, reading the letter; the face of my correspondent, staring at a coffee cup. He would have waited for the suture of words. He would have disdained the bad Impressionist painting, because objects don't much interest him. Flesh as it deposes and disposes of itself, the thumbprints and grain of character, mute signs of caring, are what his eye clicks. It has to be an eye because the ear wouldn't hear anything. We talk, when we talk, of rocks and spinach and baseball and money. We are ashamed of our paralyzing passion for the lithe son, the mystery of an <u>other</u> so alike and obdurate, the lines on a face that has been worn too long like an old glove and sat on too much like an old saddle and poked at too often like the fire of a friend, after seven years, or the eye of the self, which would cry if there weren't any men in the kitchen.

This eye, this "I," wants to be surprised at love, kidnapped. It wants Switzerland and Disneyland. It wants, with cunning, to love, and not get caught. Mr. Wolff catches. But what is the problem? Why is it necessary to ambush us in the dishabille of our affections in order to fix what is after all desirable and virtuous in the character of any man who cares about his father or his son or his friend more than he cares about kitchens and deadlines and psychologists?

Well, we aren't in this brave new world, hunters or warriors or Fisher Kings, Mafiosi or Châteaubriands, bandits, pirates, Rockefellers, Black Barts, Billy Budds, Napoleon, Peter the Great, Casanova, Abraham Lincoln, Woody Allen, García Márquez, Bob Dylan or Captain Kangaroo. We buckle more often than we swash. We are not men; we are anal-rententive opinions about the clitoris and honor. We lack panache and chutzpah. We will never build a railroad through the brains of tribes of grass-eating, rain-dancing Indians. We no longer have the right, or the delusion.

I submit that men tend to avoid, evade, dissemble, run away, smirk, stamp our feet, listen to rock music and feel bad in the middle of the night because—deep down, in the kitchen, where the shame is—we suspect ourselves of not being very _interesting_. We will be found out. If we can't be king, we might as well watch "Kojak." When we fall in love, it is because somebody mysteriously believes that there is more to us than a bad Impressionist painting, and we have to love the somebody who believes it. Take away our money, and we're scared. Please, I'm only kidding. I work because it is difficult for me to feel; or, if I felt, you would laugh at me because when was the last time I slew a dragon? We are obsolete.

Except that Bernard Wolff has rendered us charming, like dolphins. He has reminded the rest of the militant world that we have seizures of feeling, are suspected of love, might die for our friends and are not strangers to nests and webs.

<div align="right">JOHN LEONARD</div>

New York
May 1978

Friends and Friends of Friends

We cannot tell the precise moment when friendship is formed. As in filling a vessel drop by drop, there is at last a drop which makes it run over; so in a series of kindnesses there is at last one which makes the heart run over.

JAMES BOSWELL

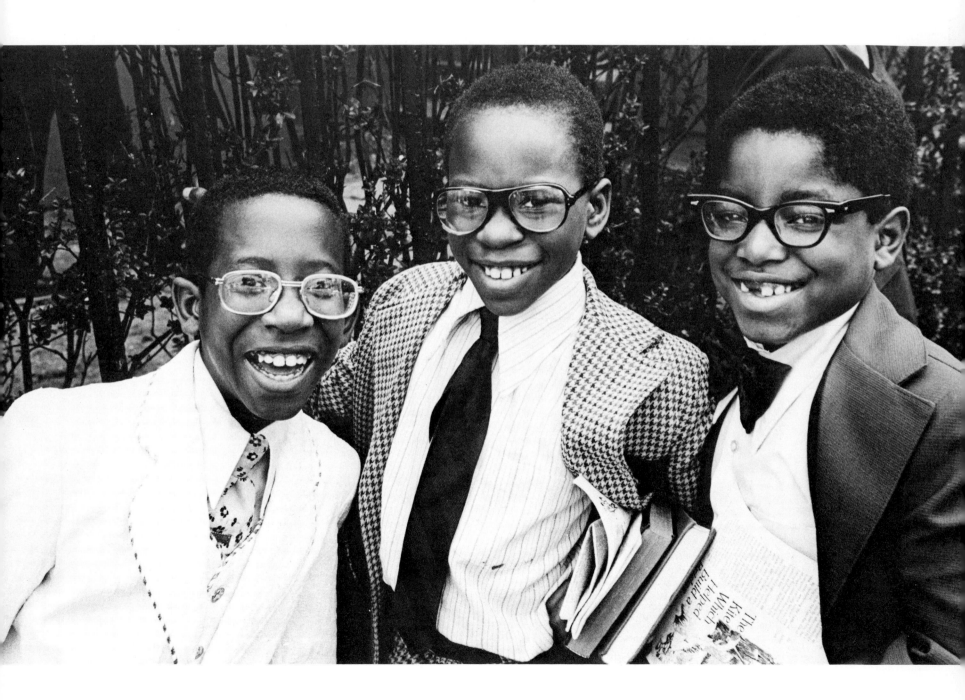

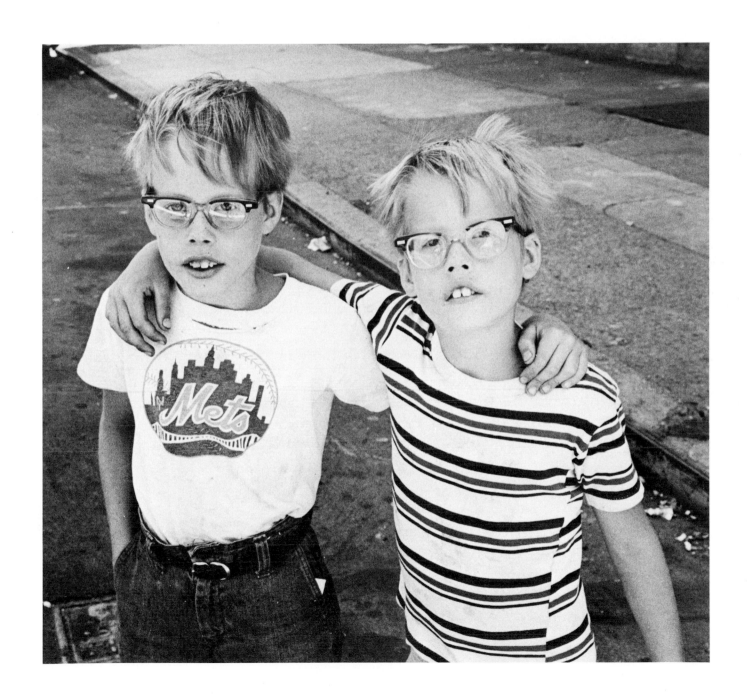

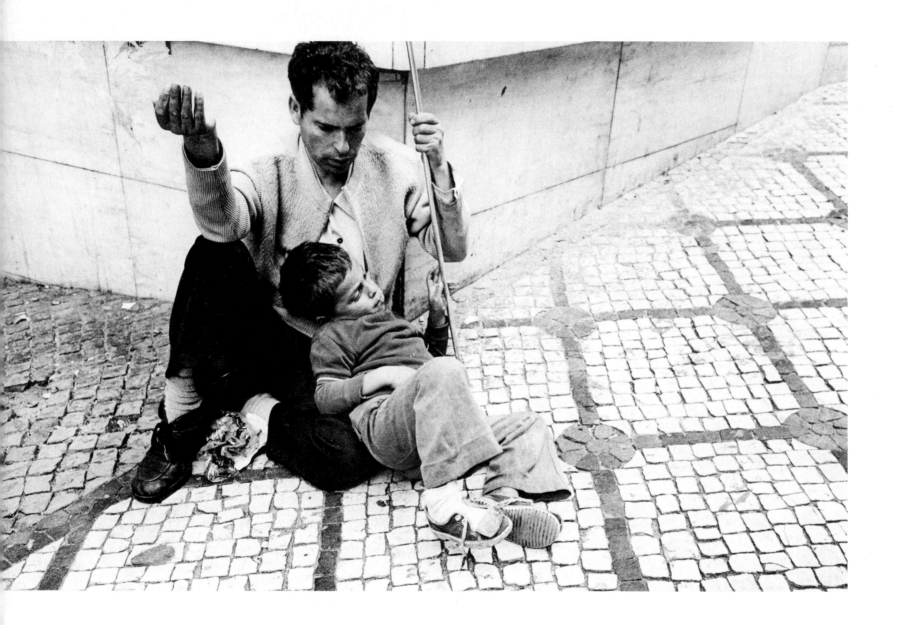

4

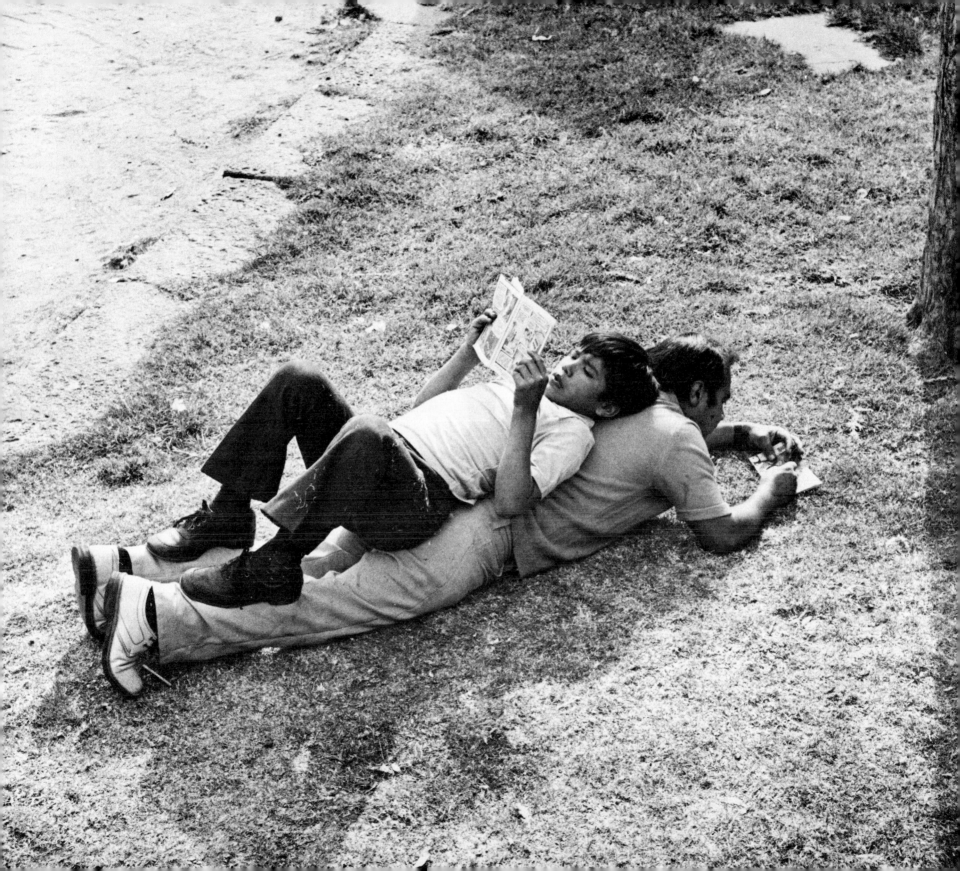

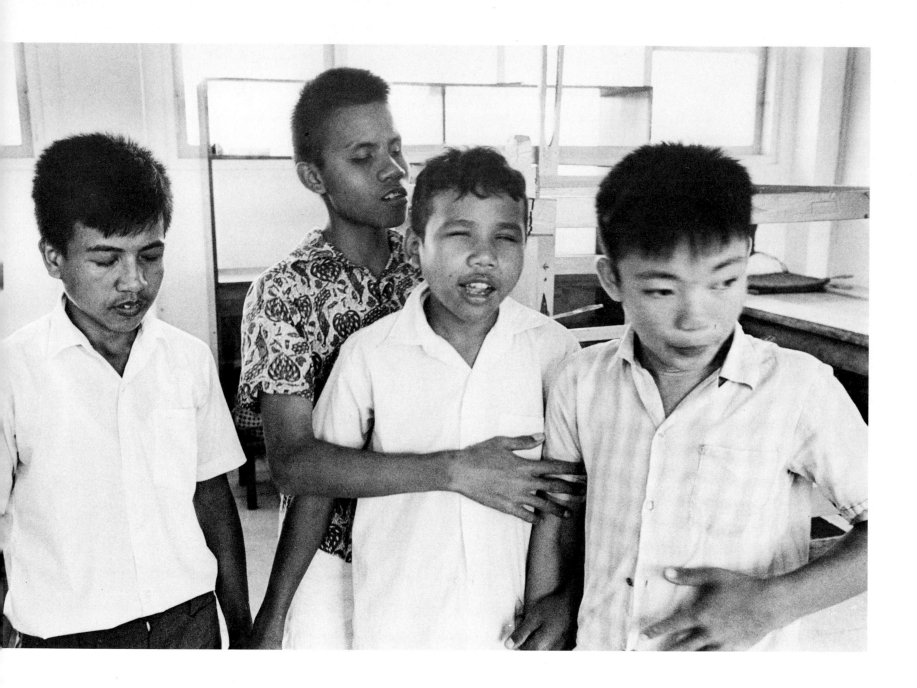

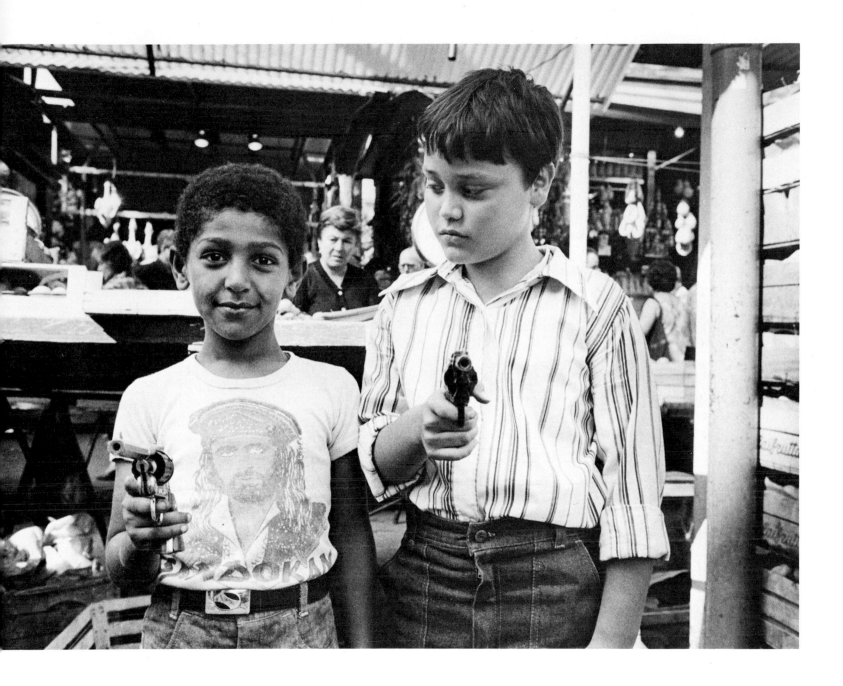

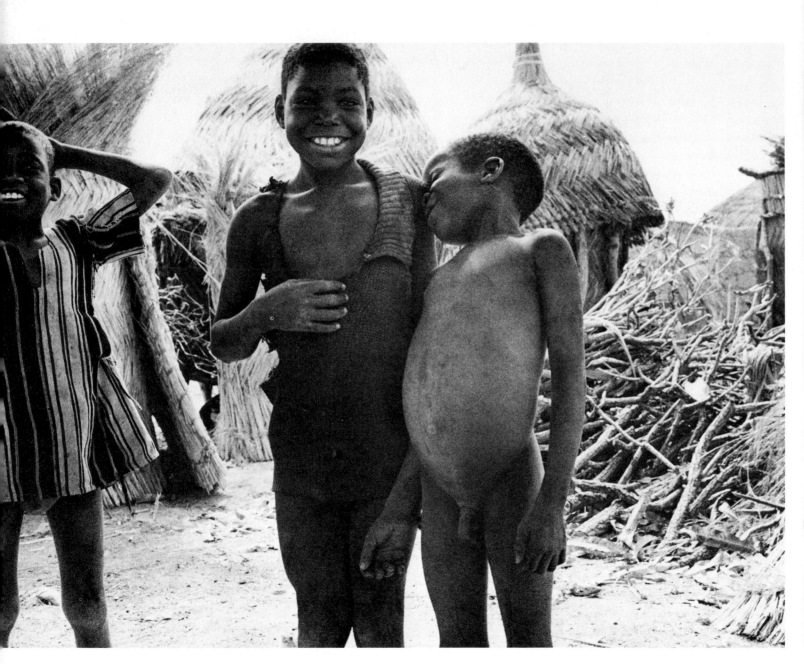

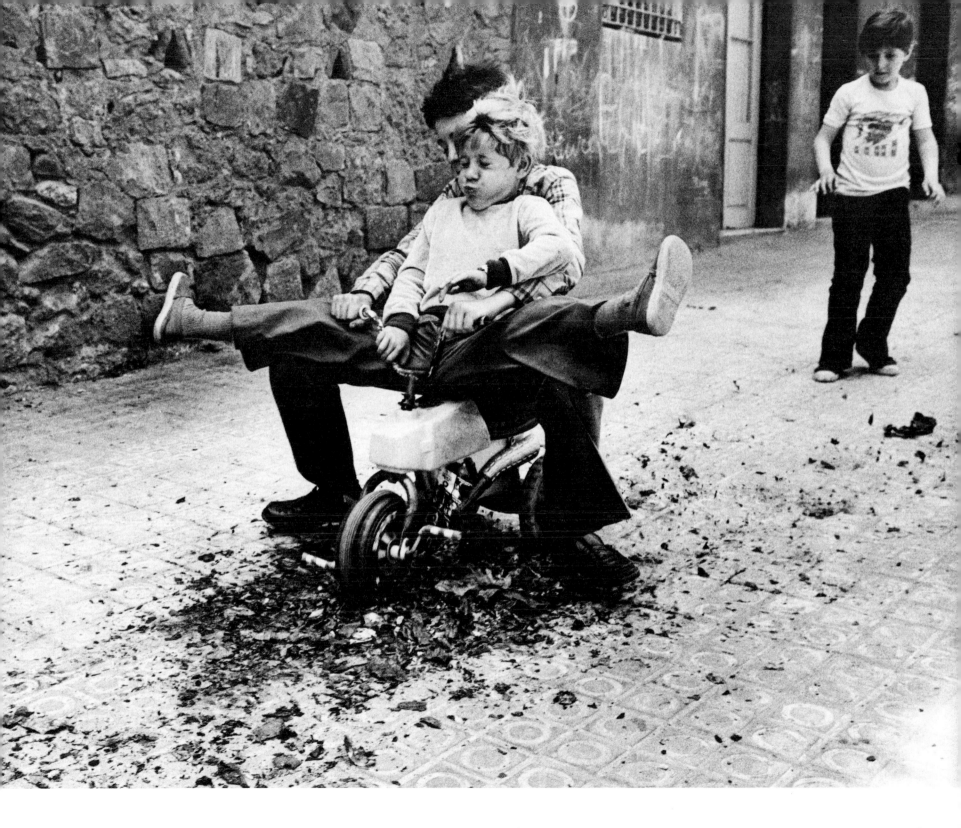

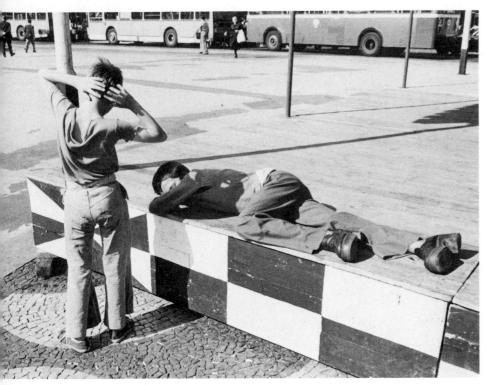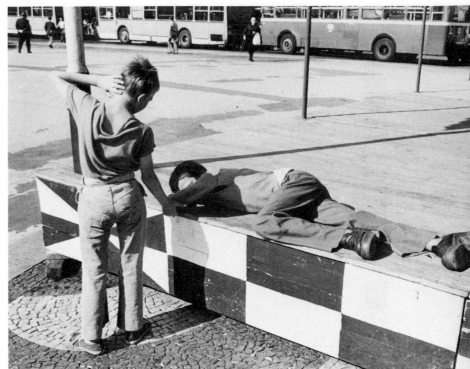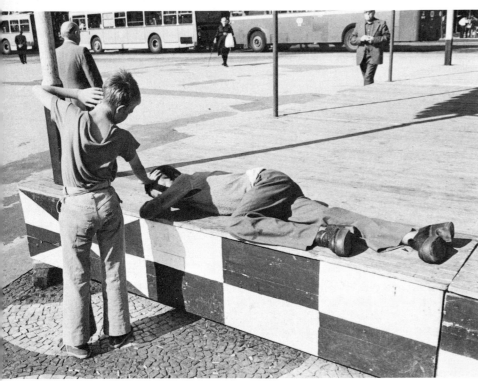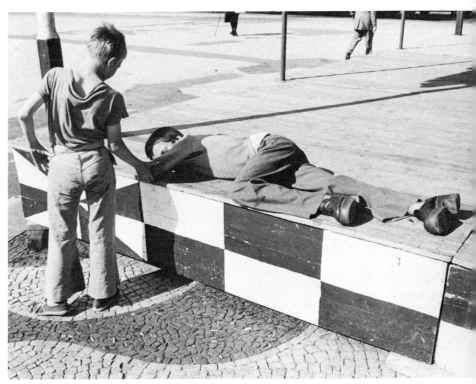

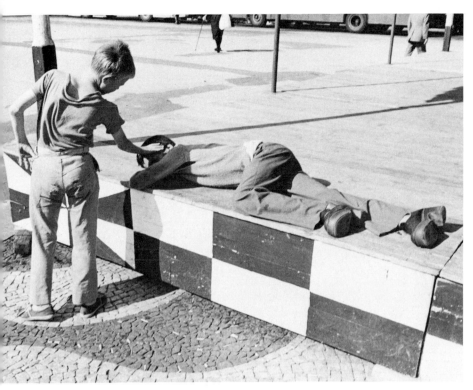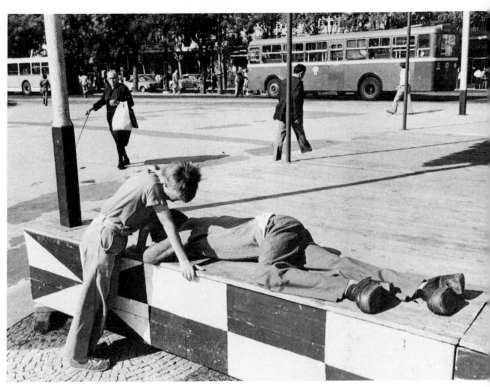
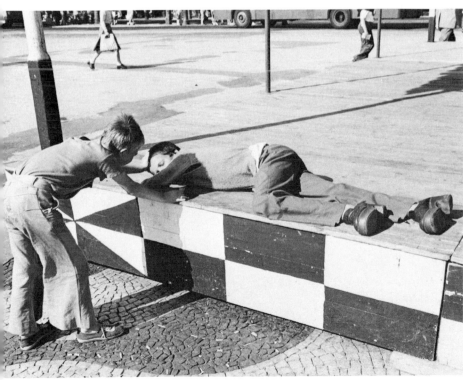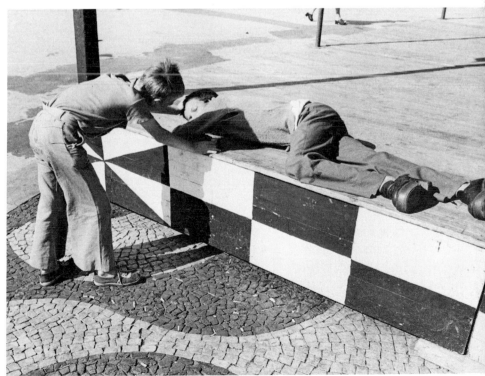

Friends are born, not made.

HENRY BROOKS ADAMS

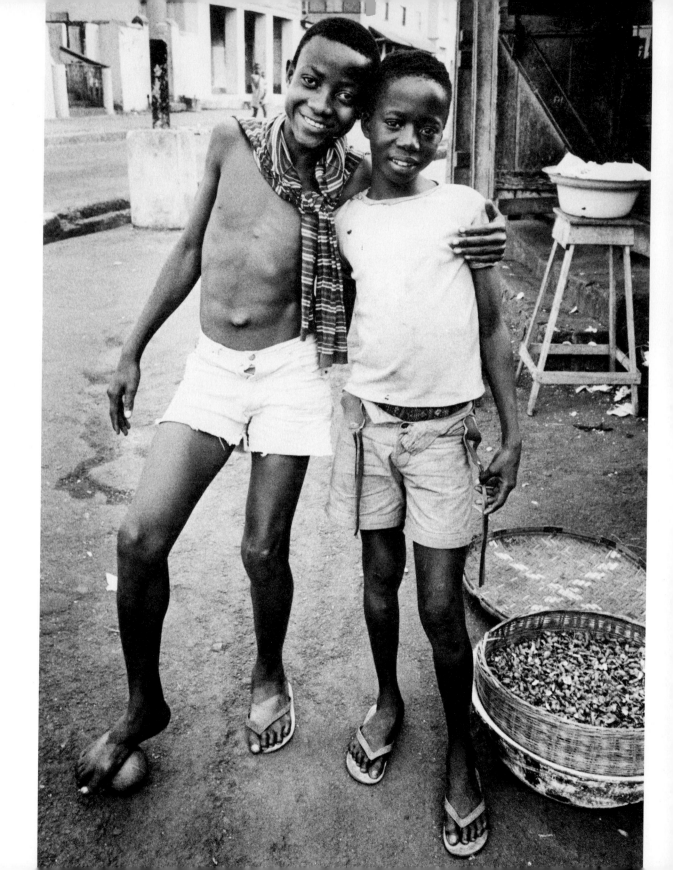

14

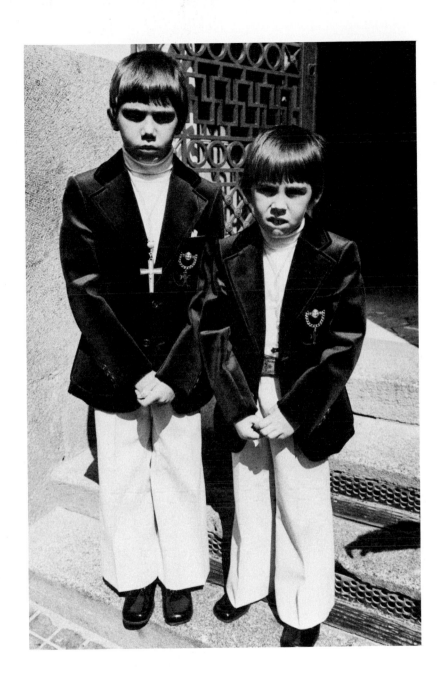

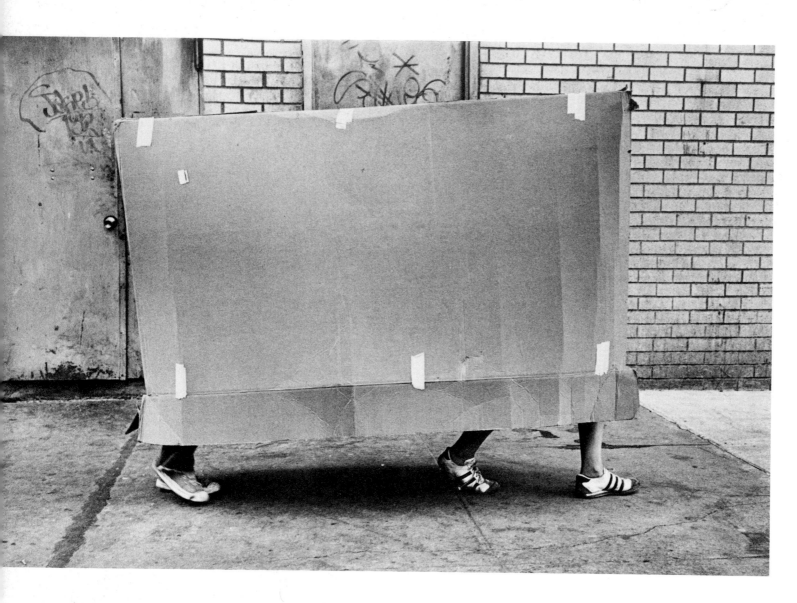

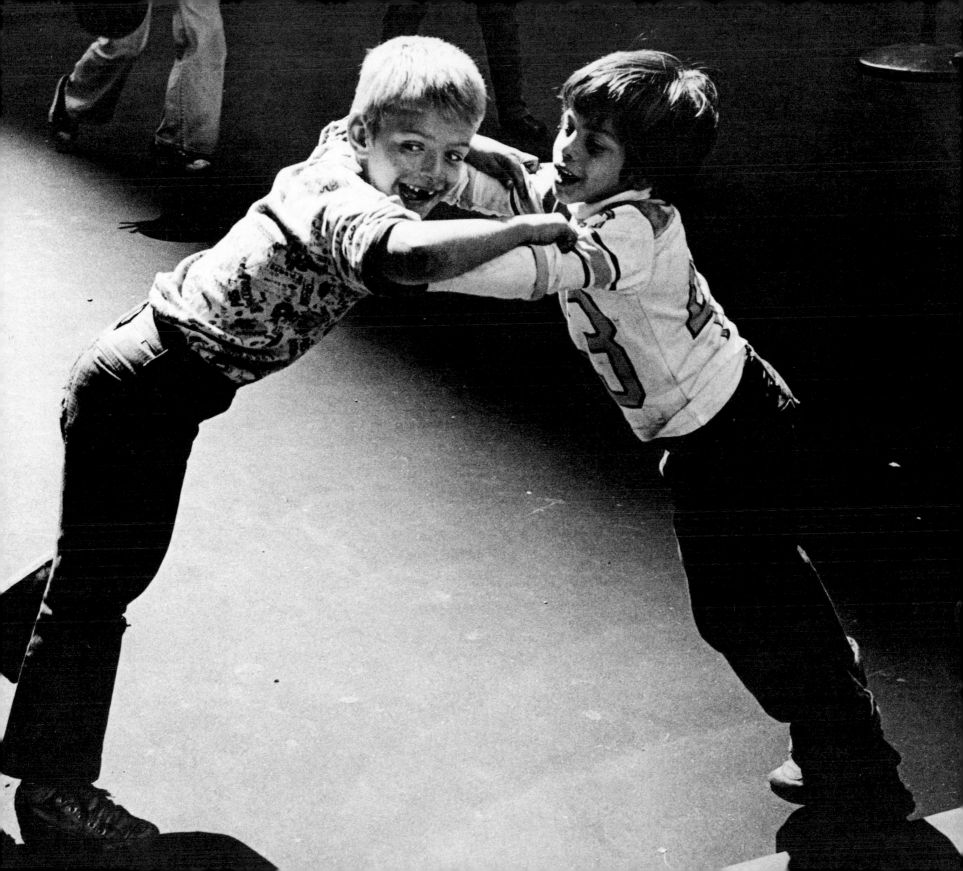

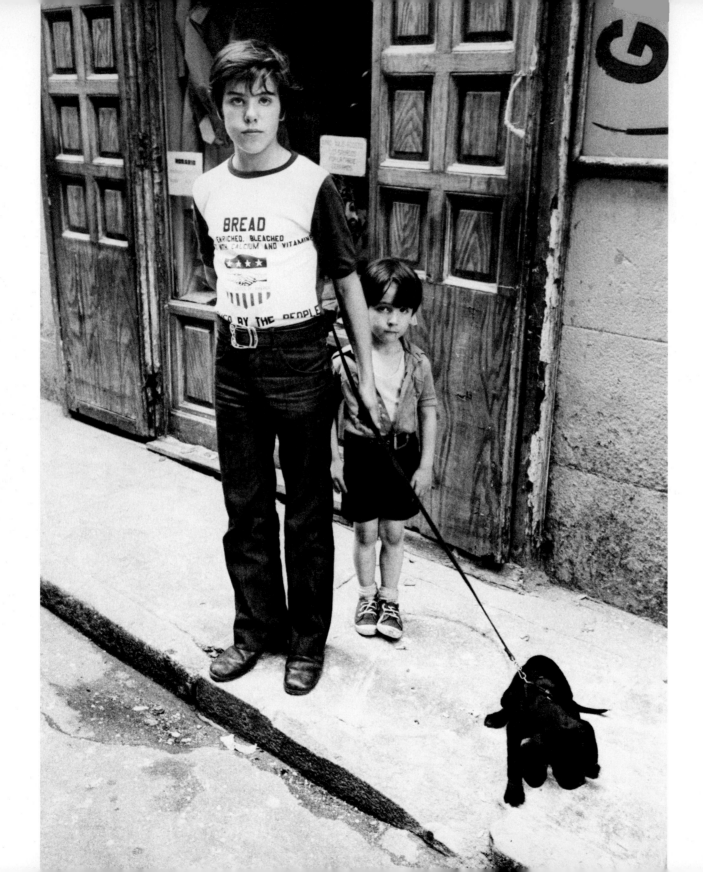

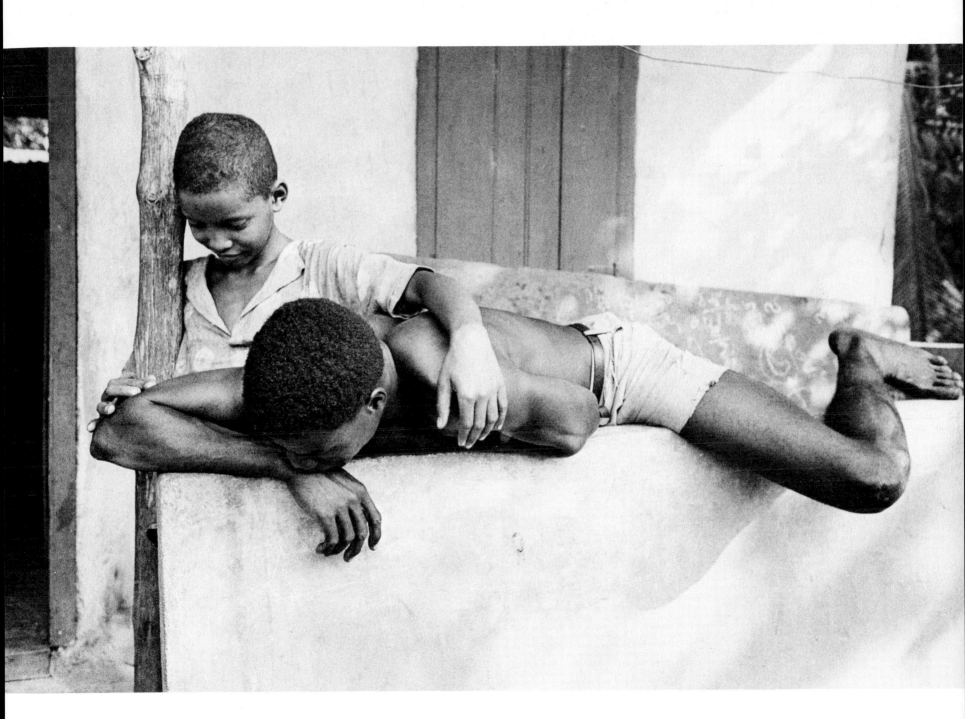

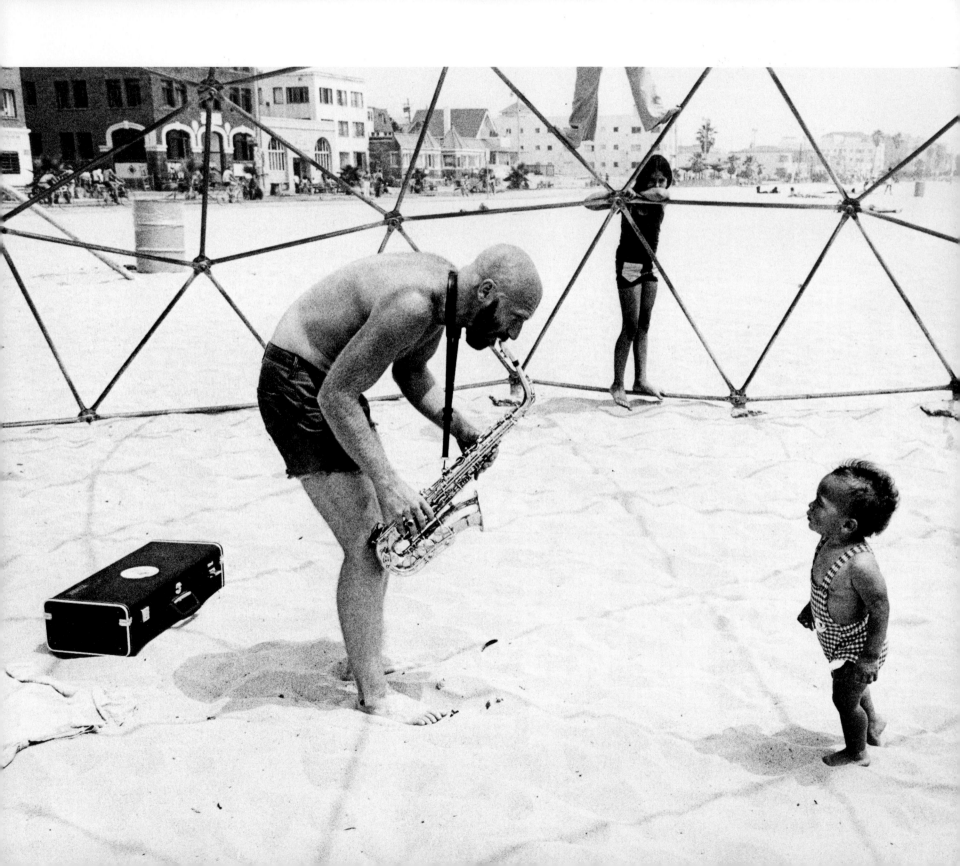

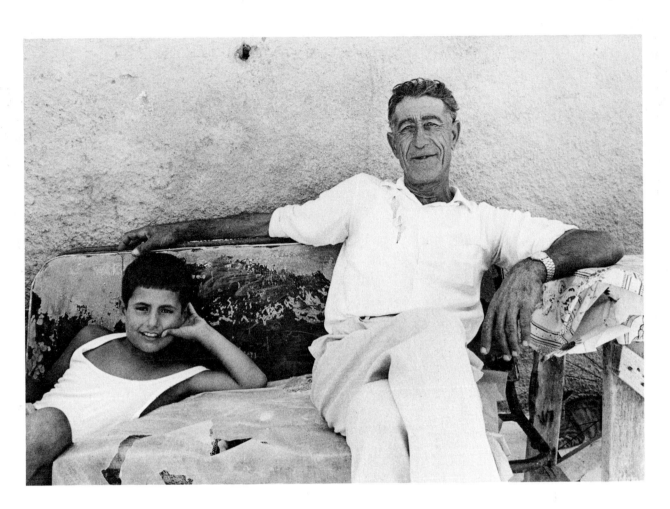

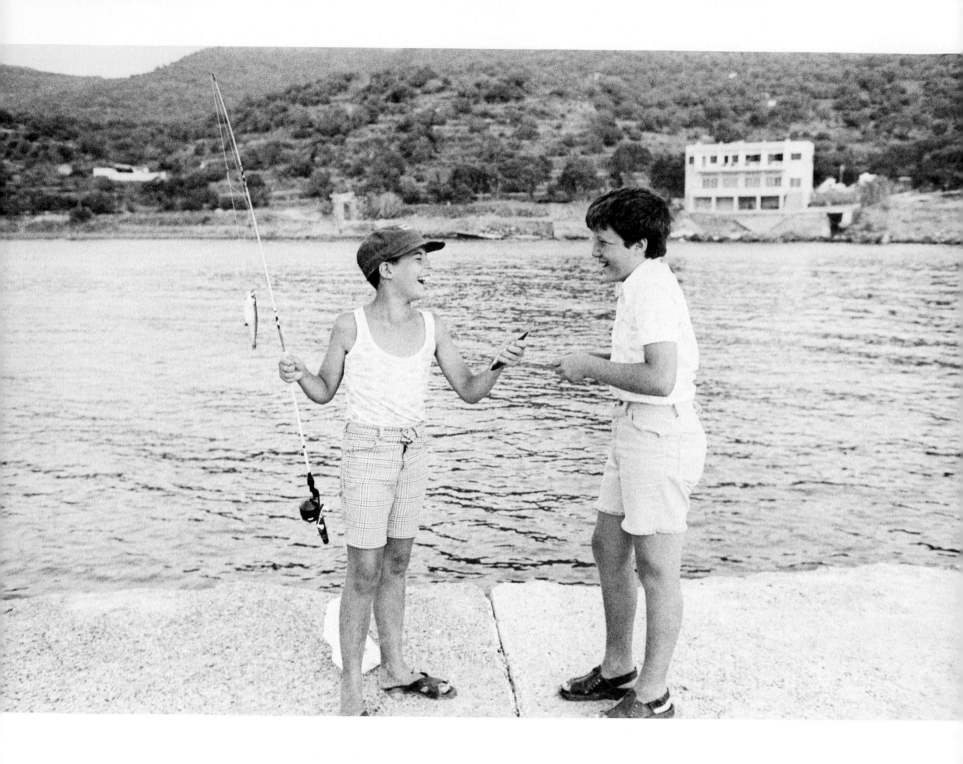

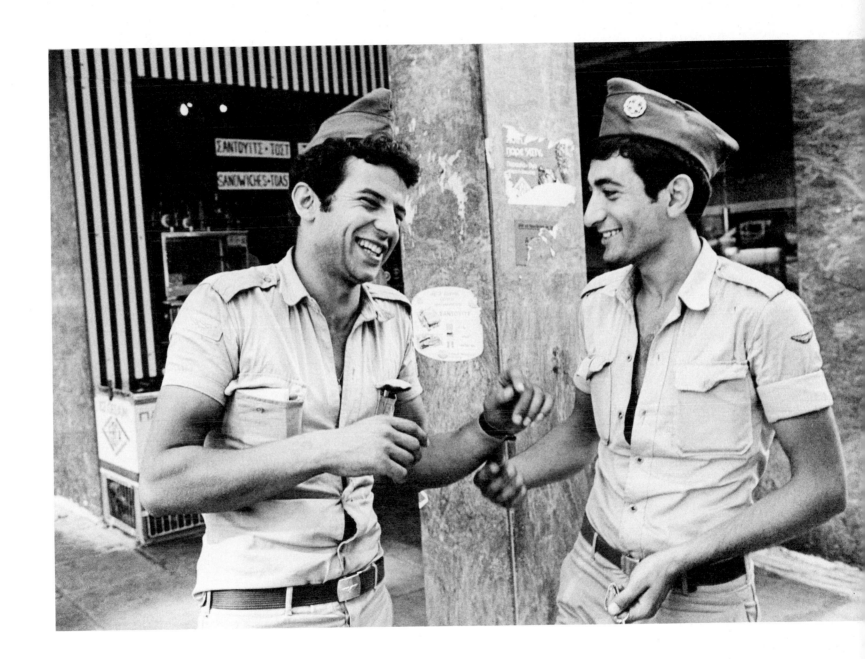

Be slow in choosing a friend, slower in changing.

BENJAMIN FRANKLIN

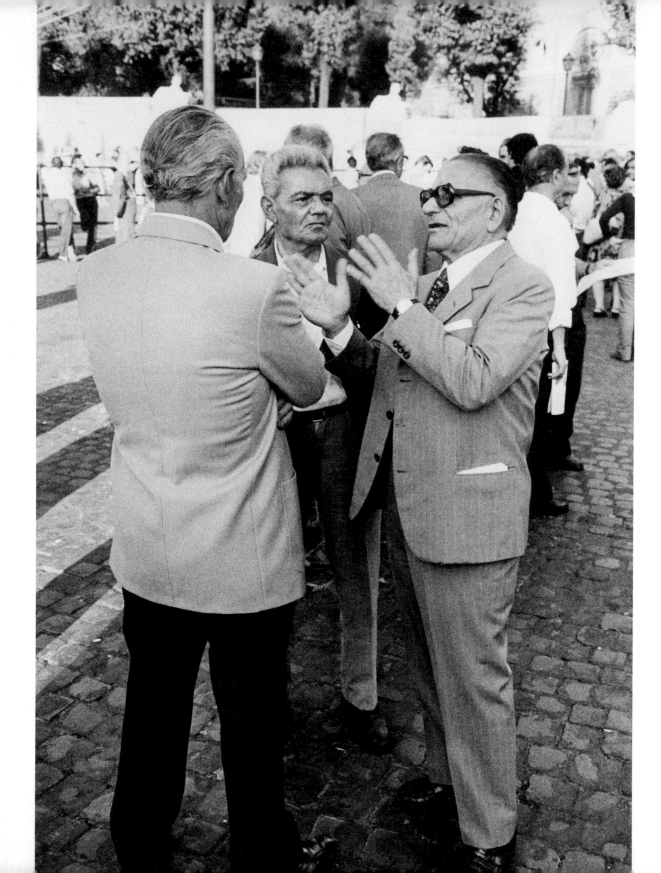

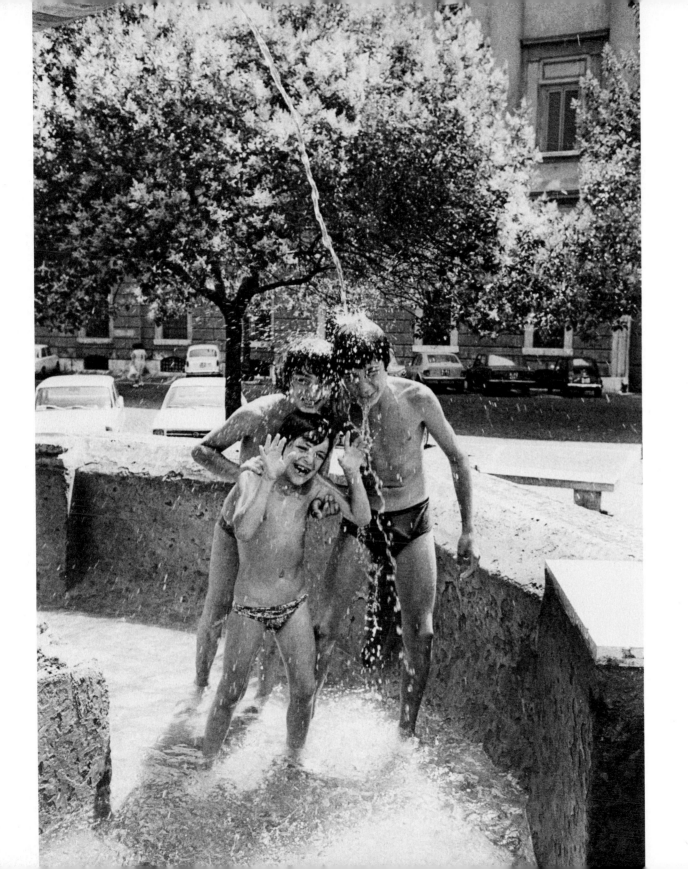

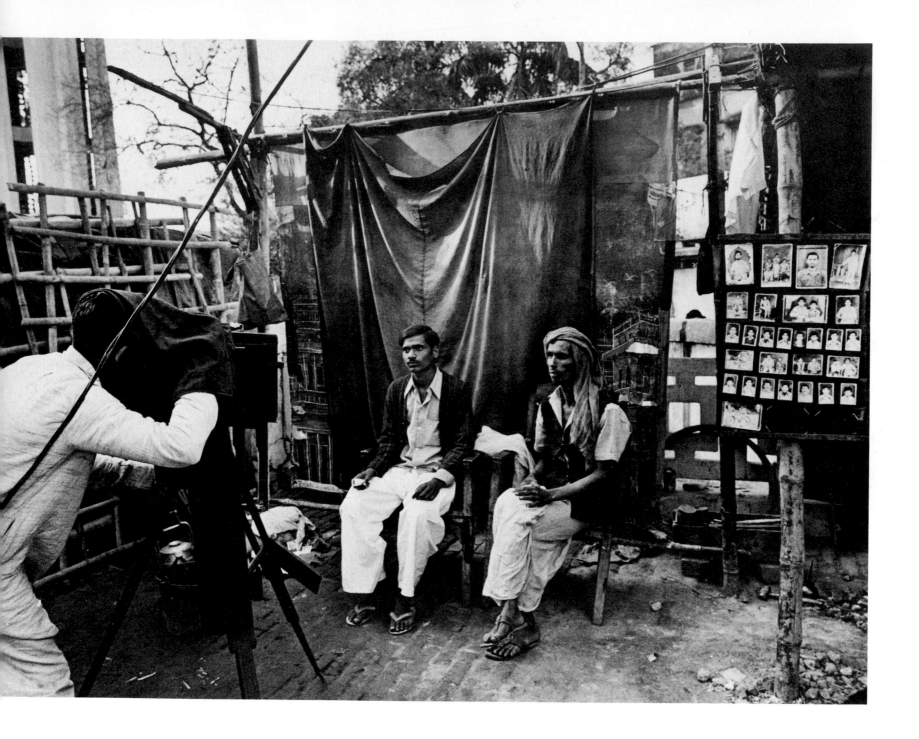

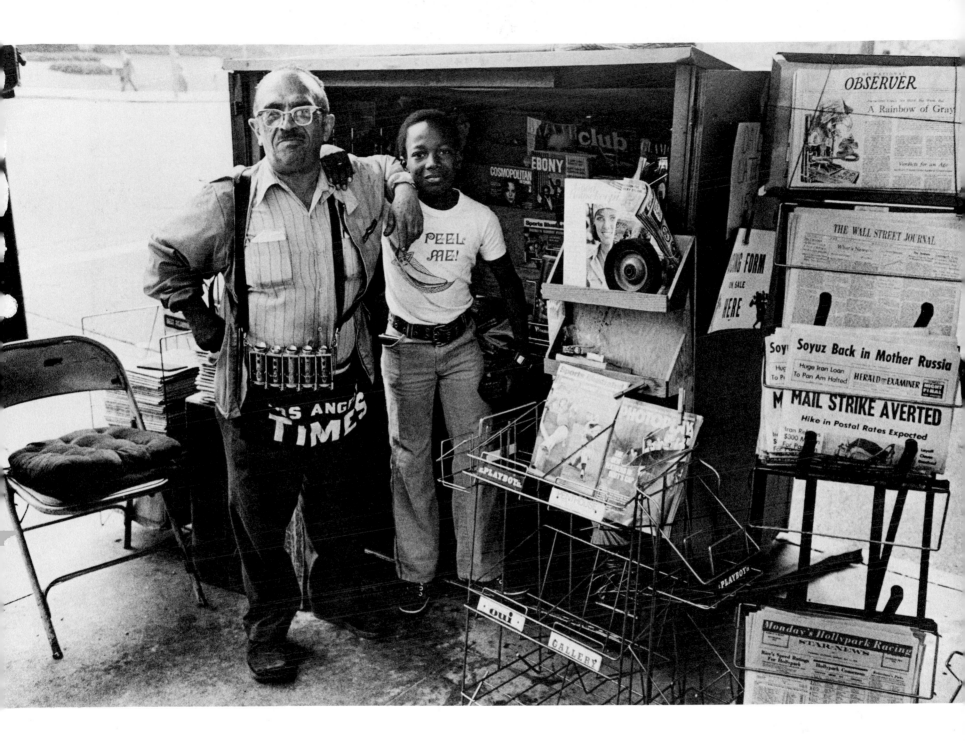

29

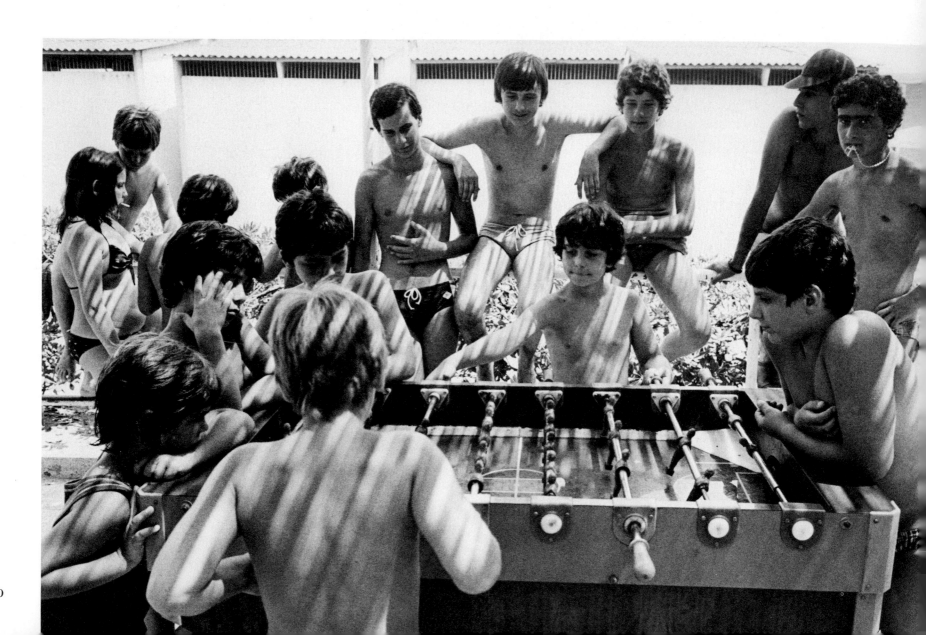

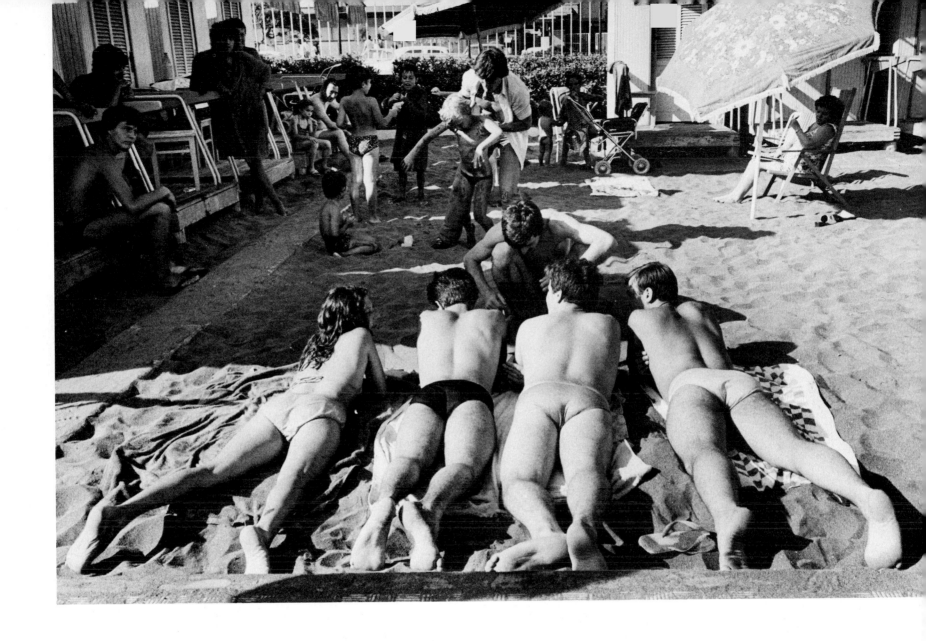

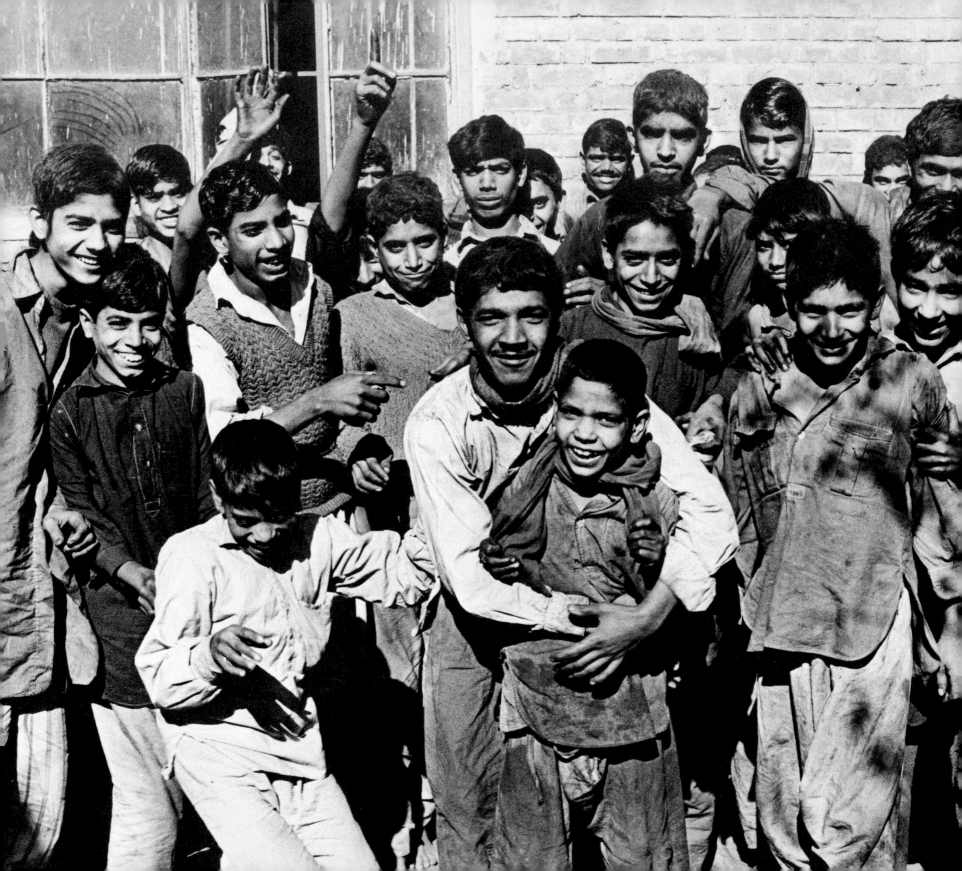

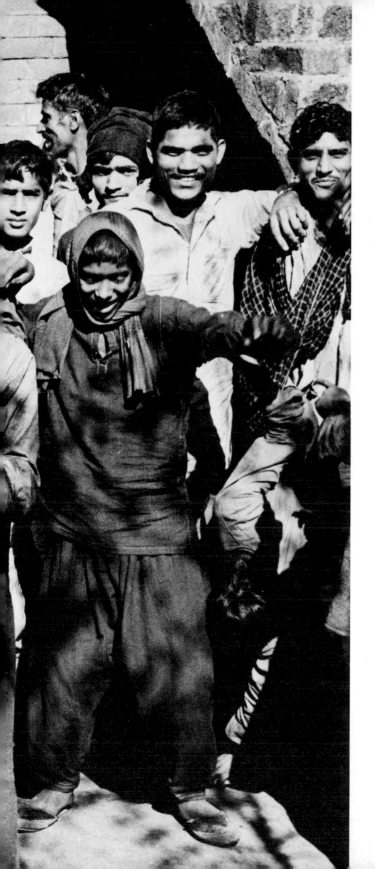

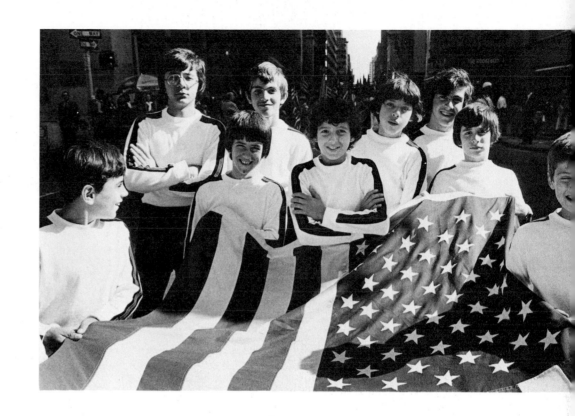

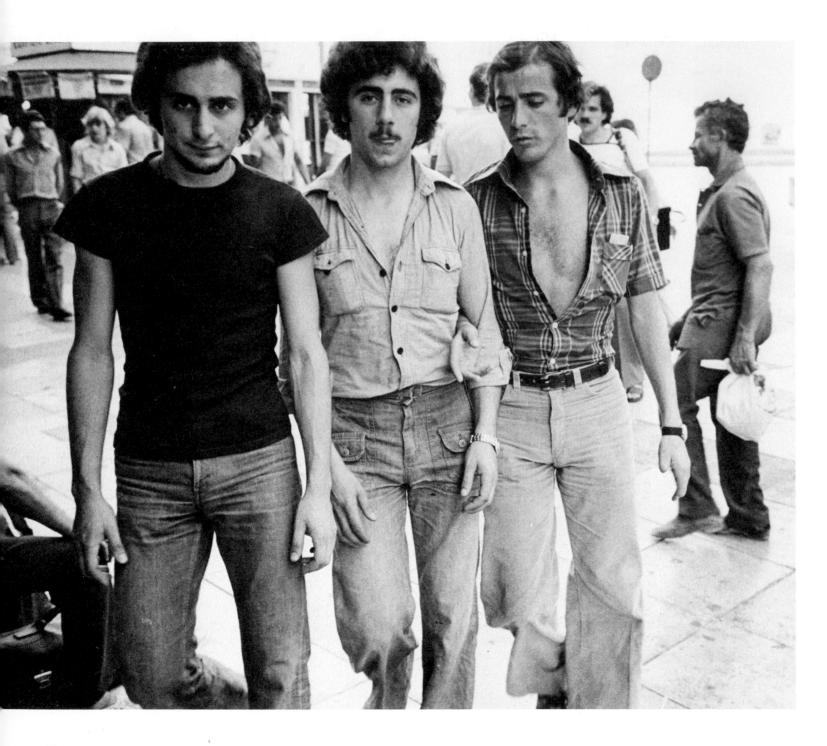

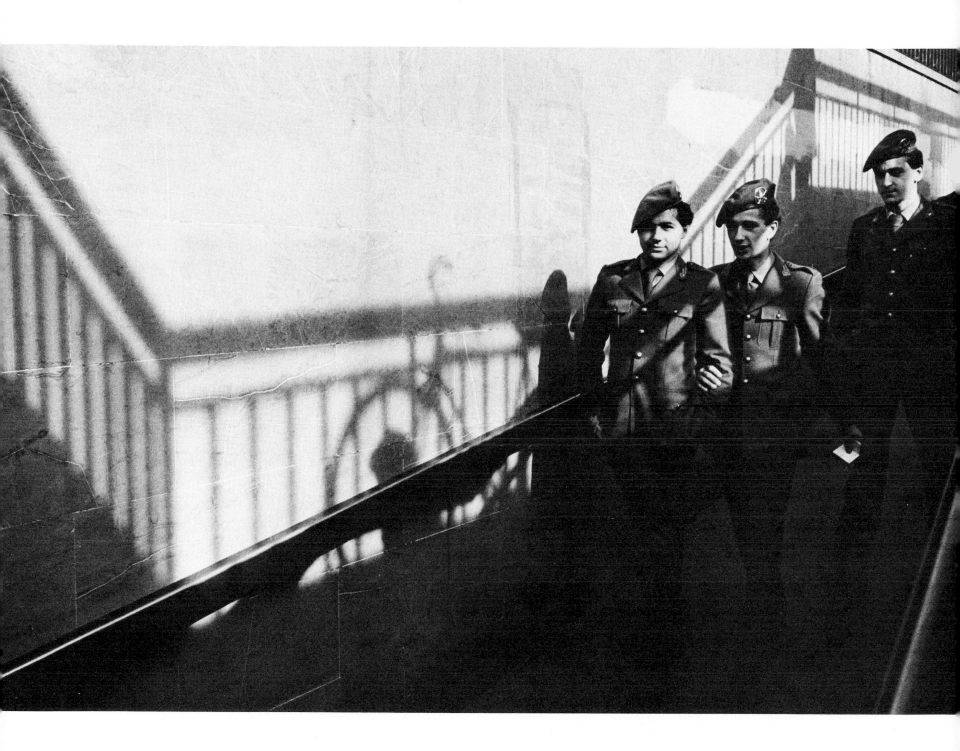

A friend is one who warns you.

NEAR EAST PROVERB

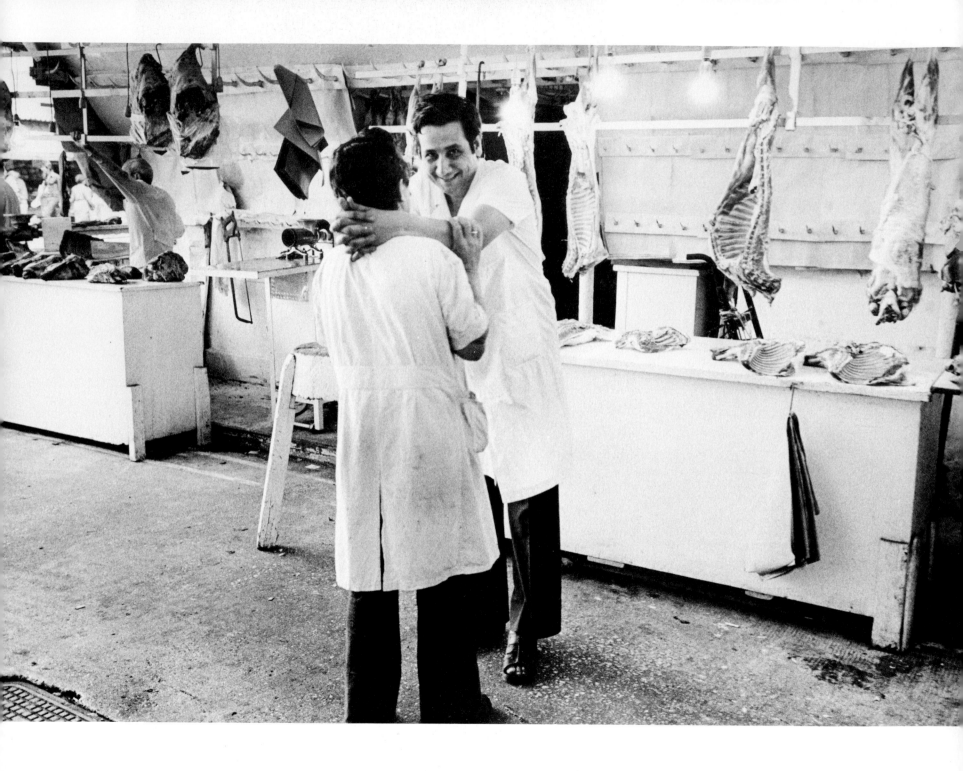

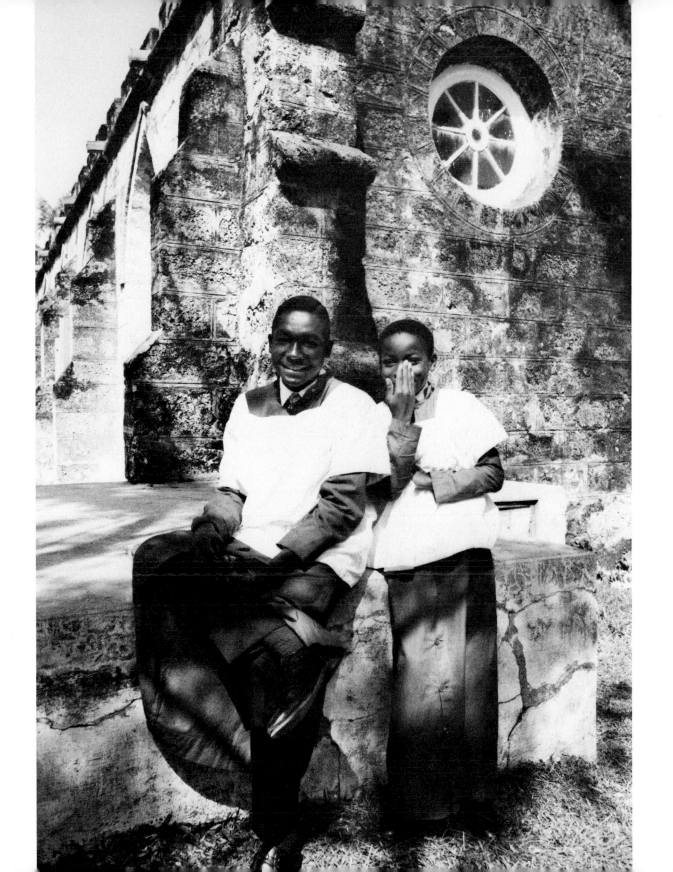

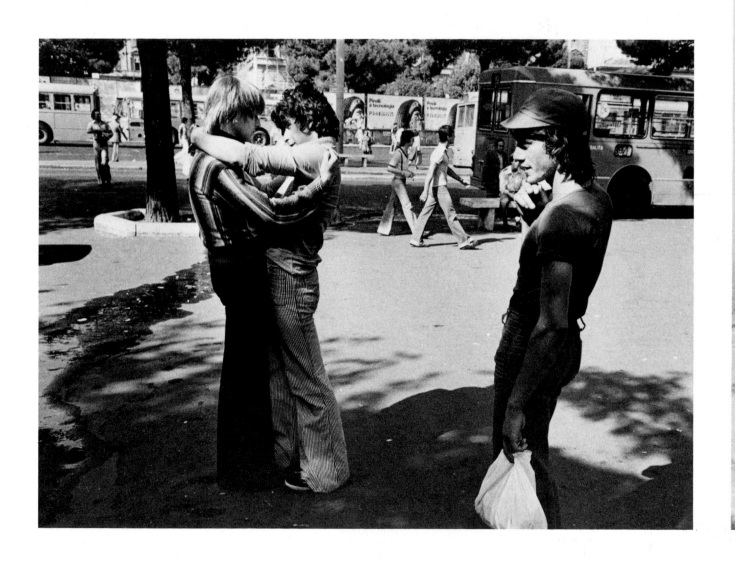

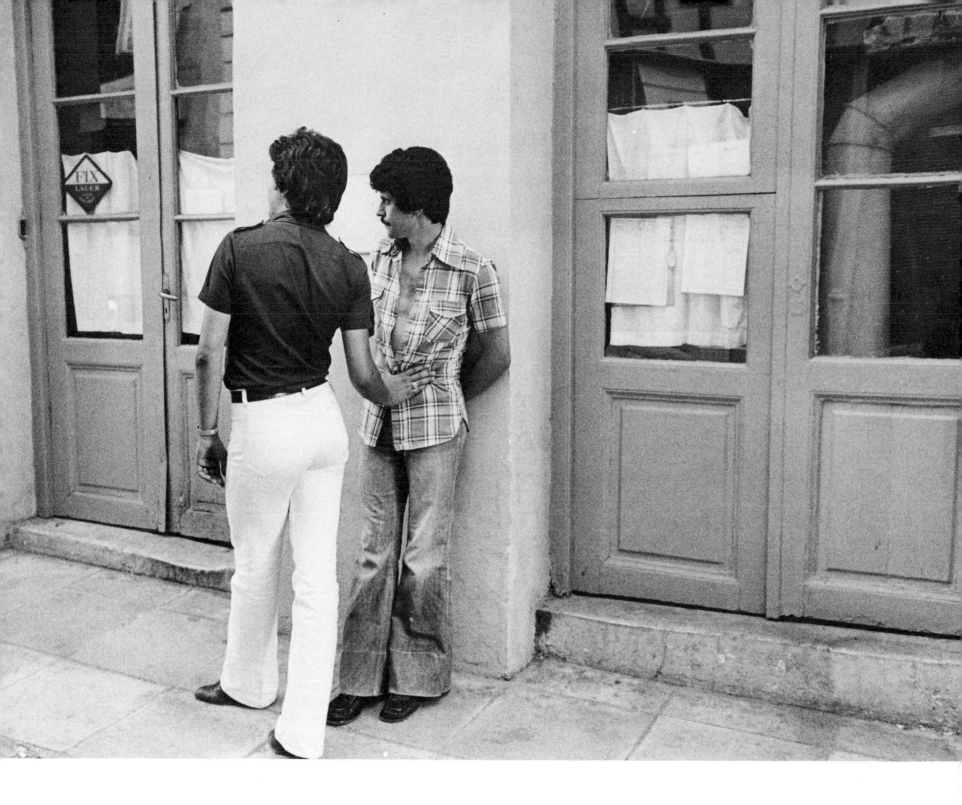

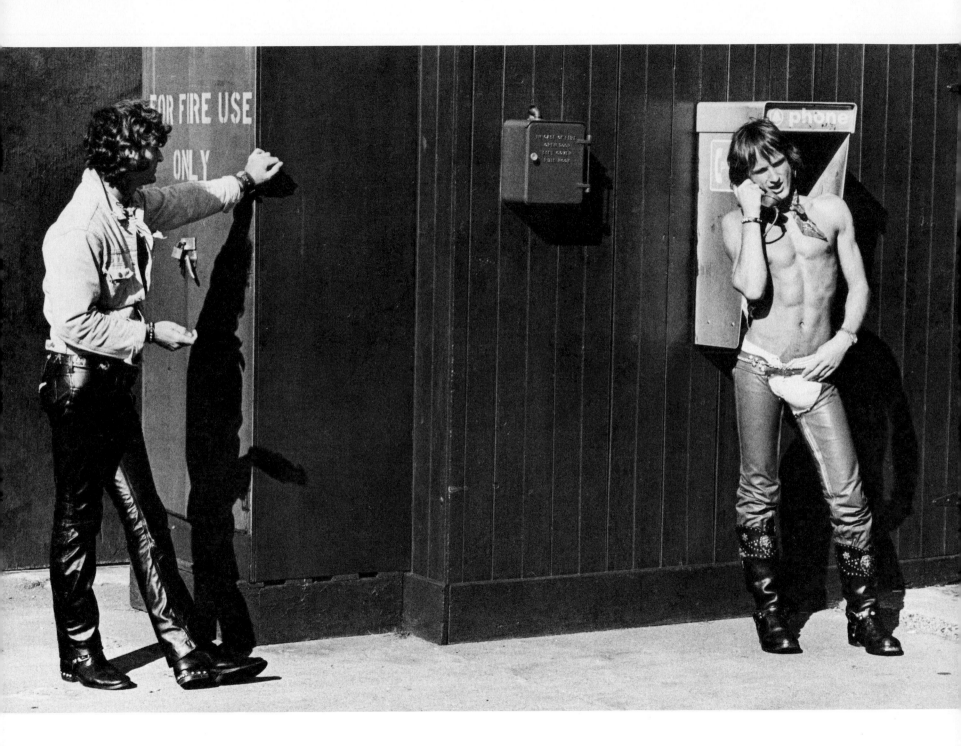

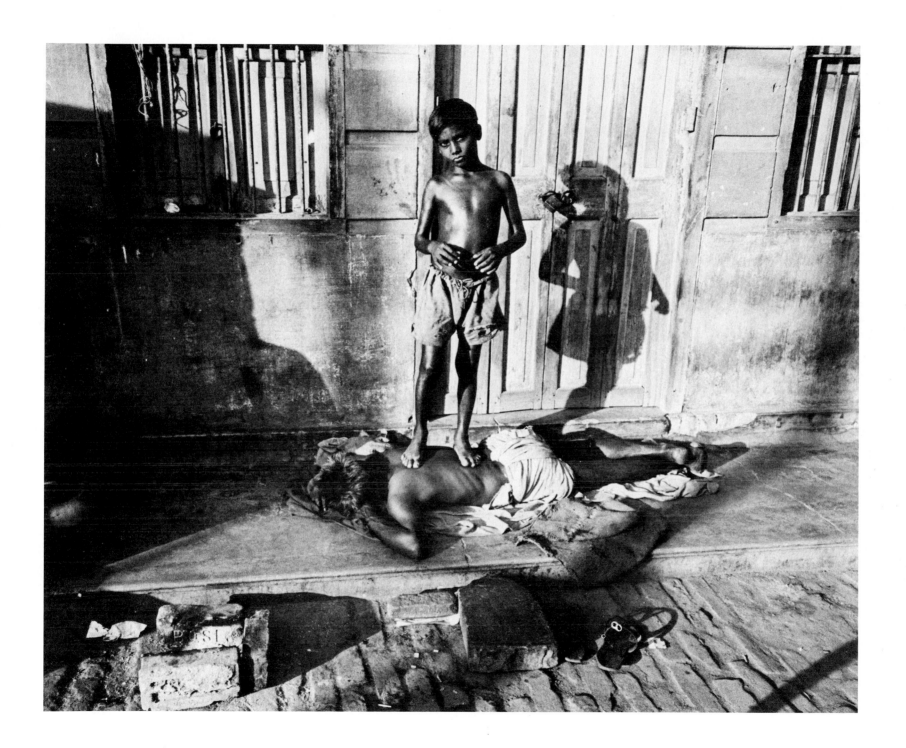

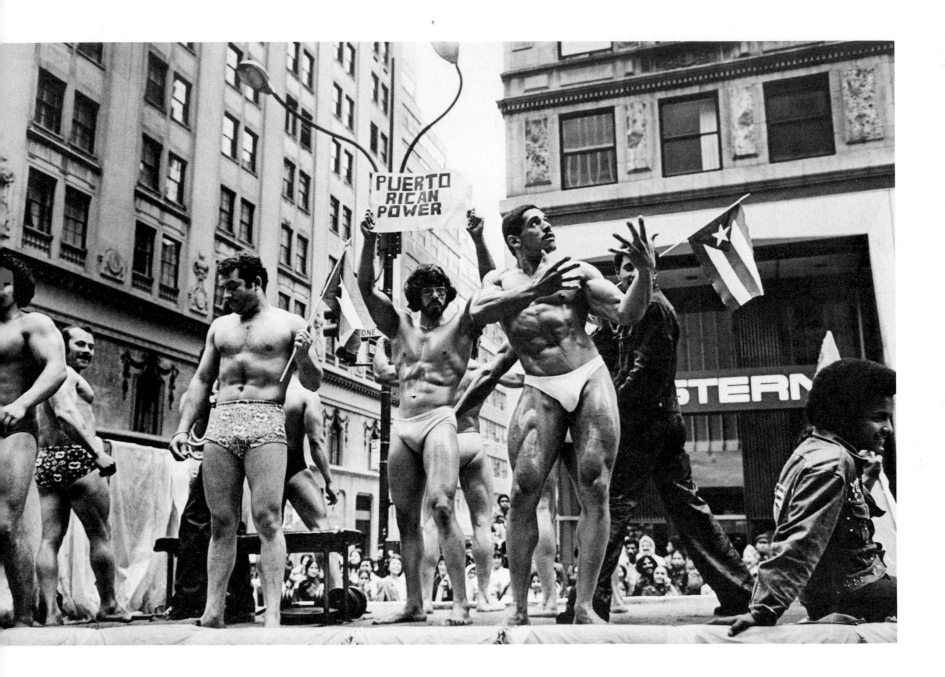

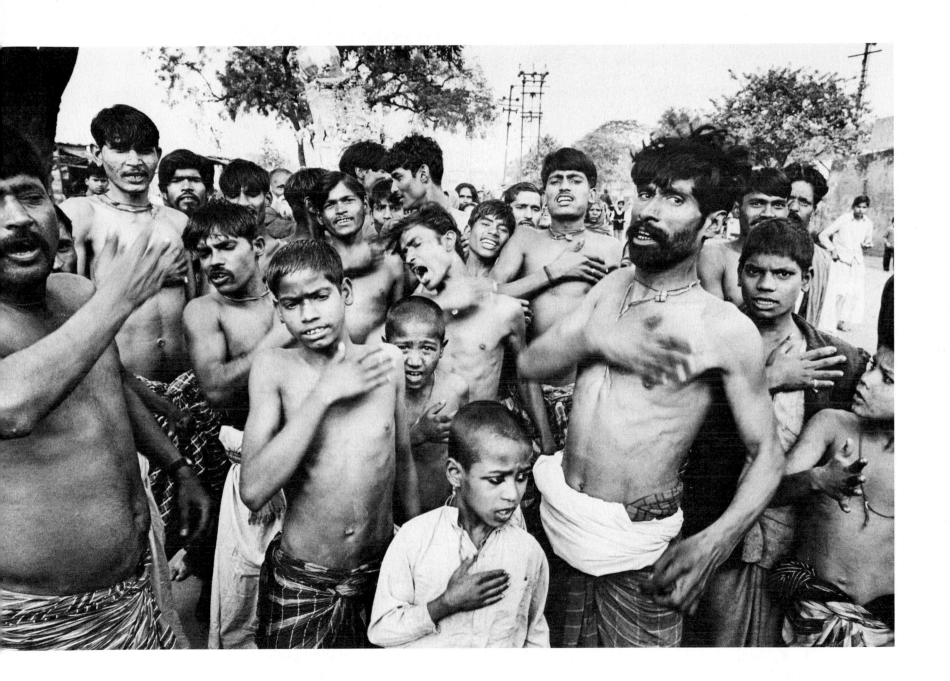

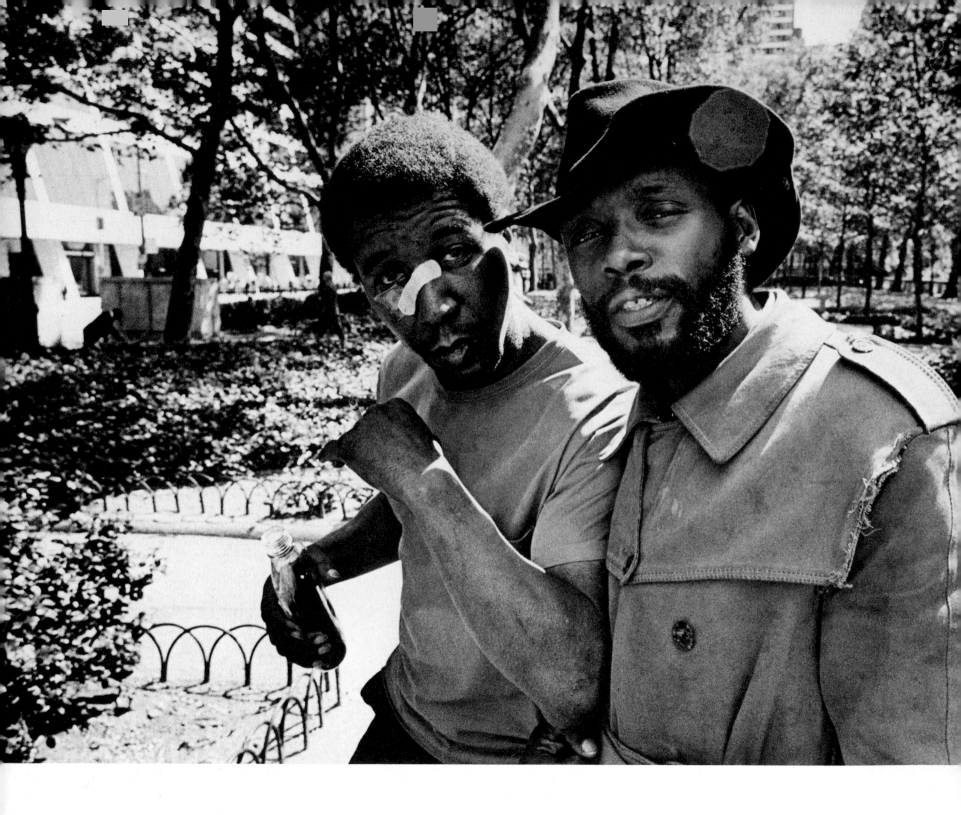

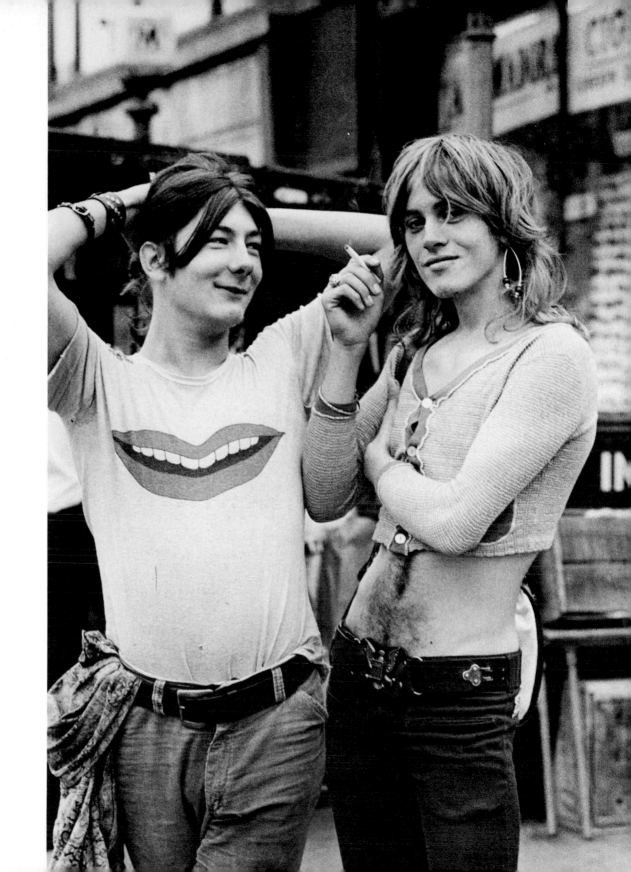

When I say friends, I mean friends. Not anybody and everybody can be your friend. It must be someone as close to you as your skin, someone who imparts color, drama, meaning to your life....A life without friends is no life, however snug and secure it may be.

HENRY MILLER

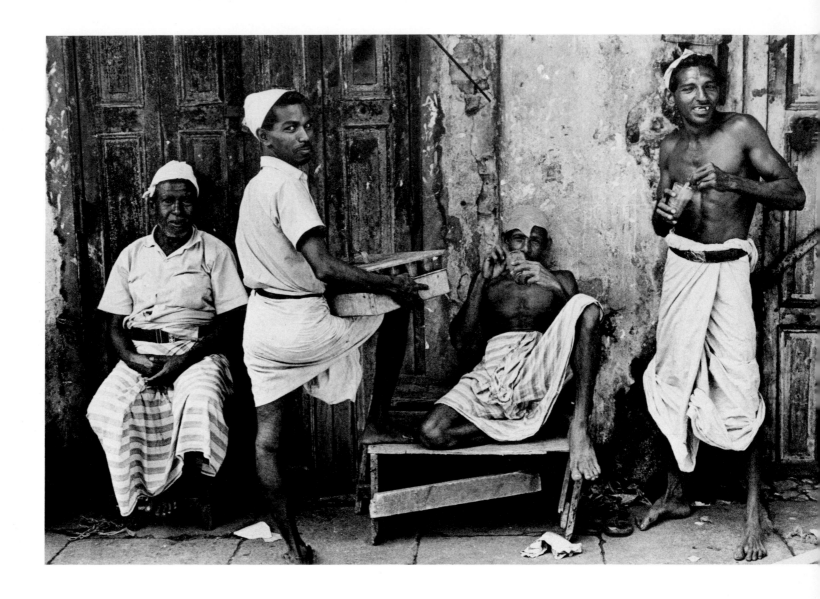

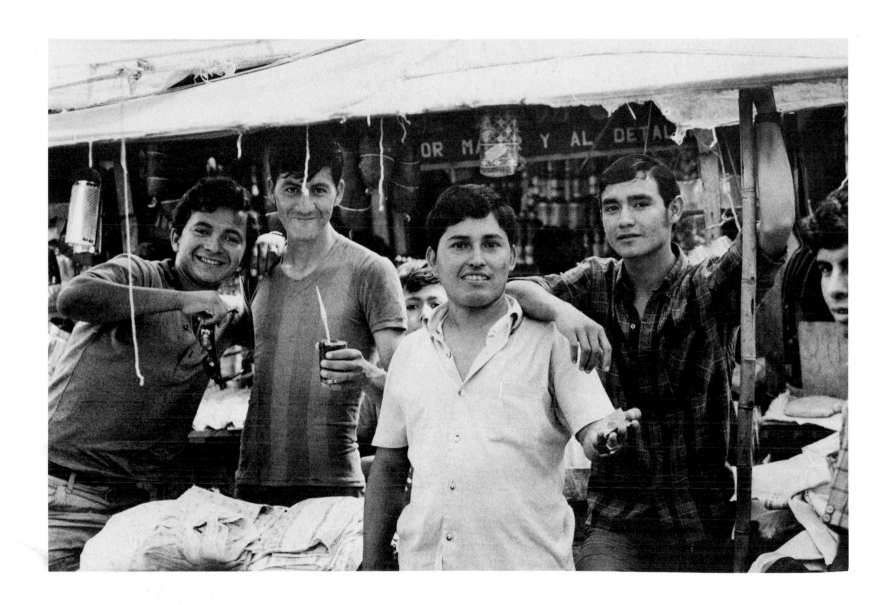

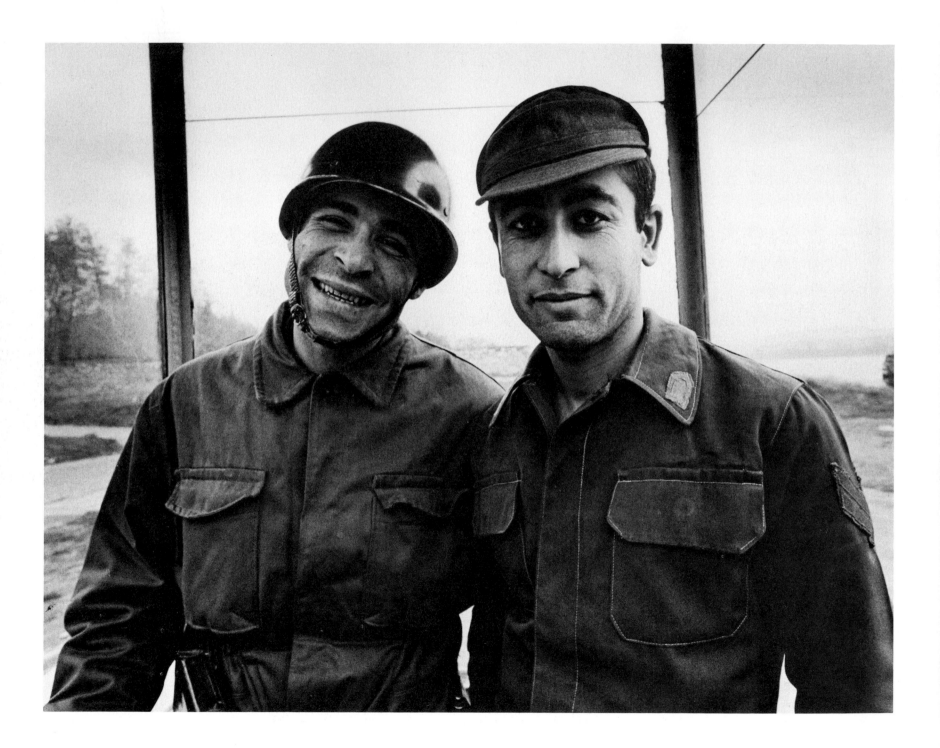

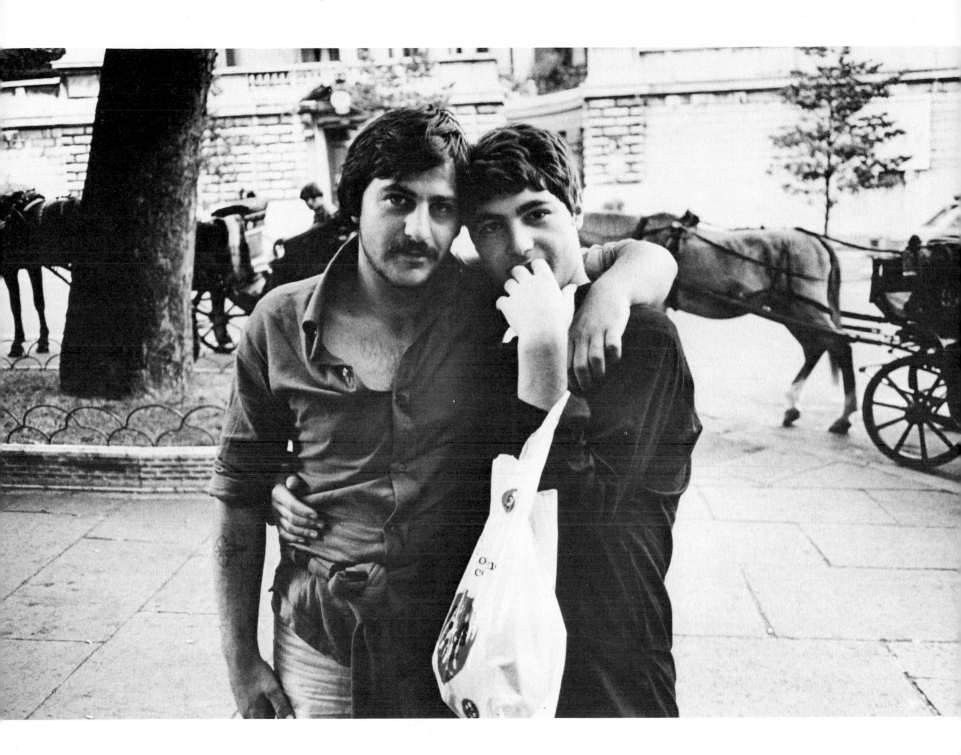

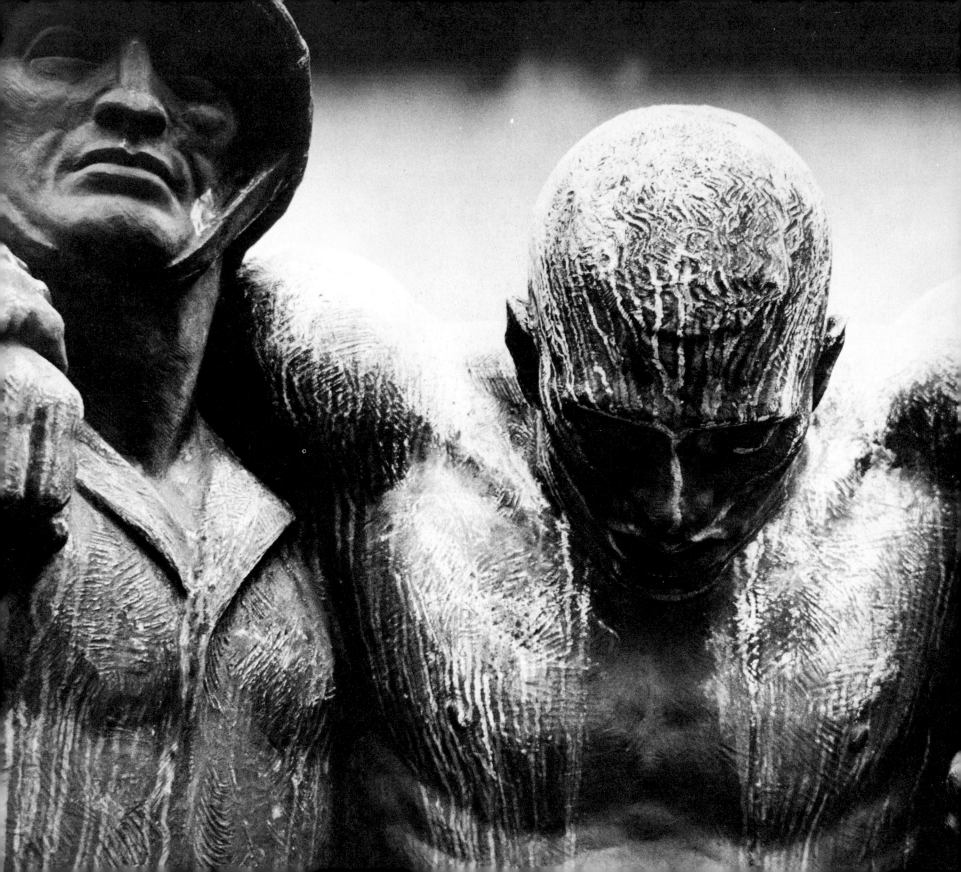

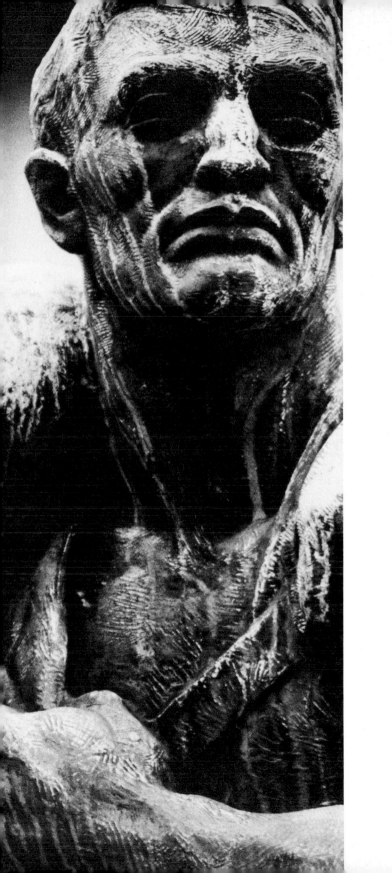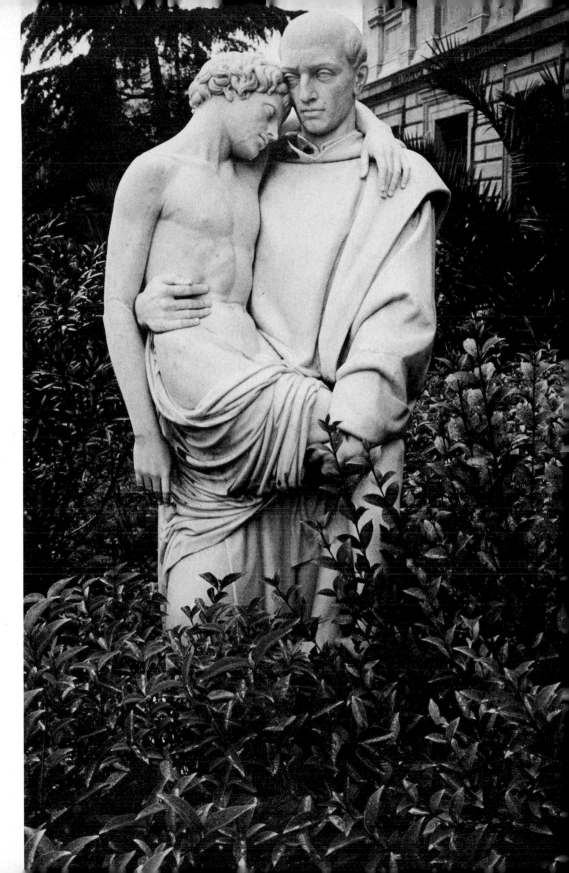

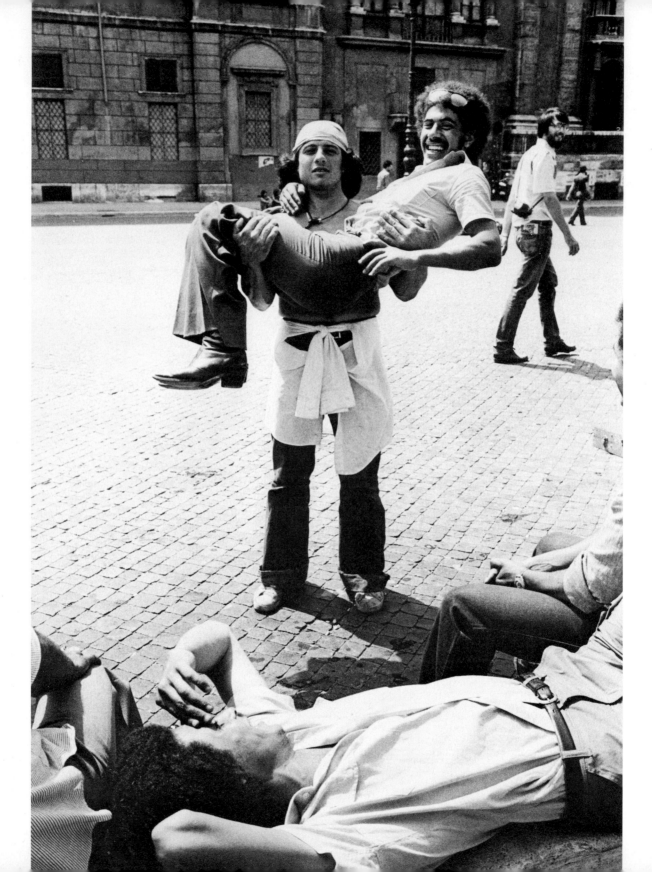

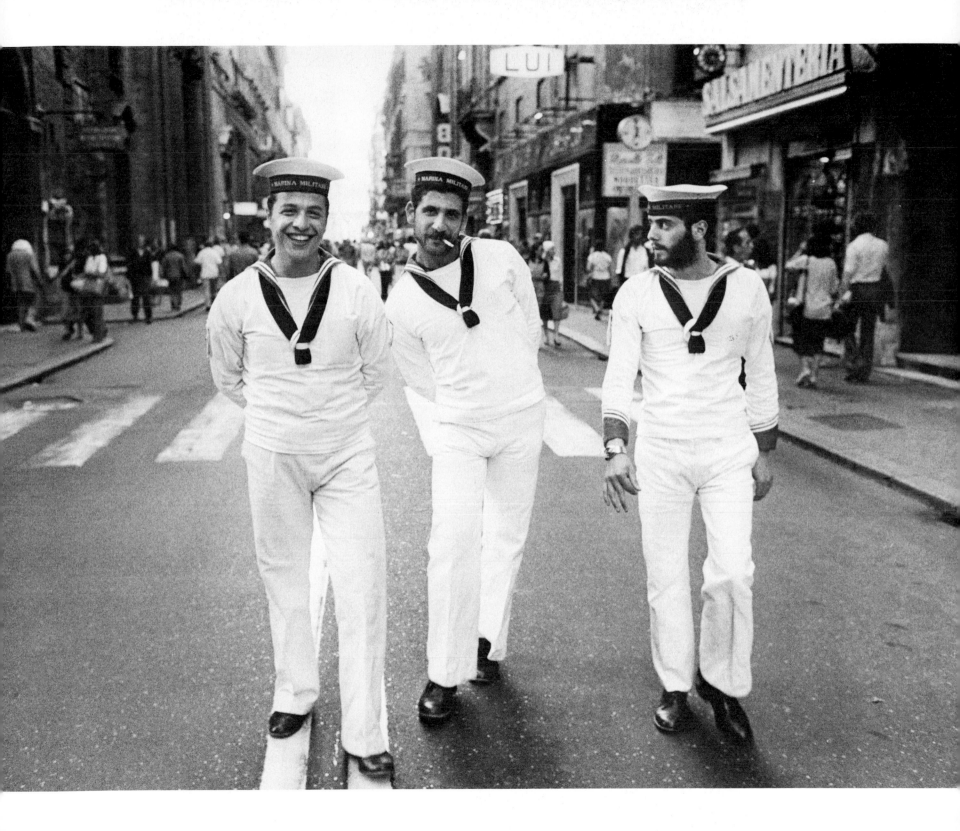

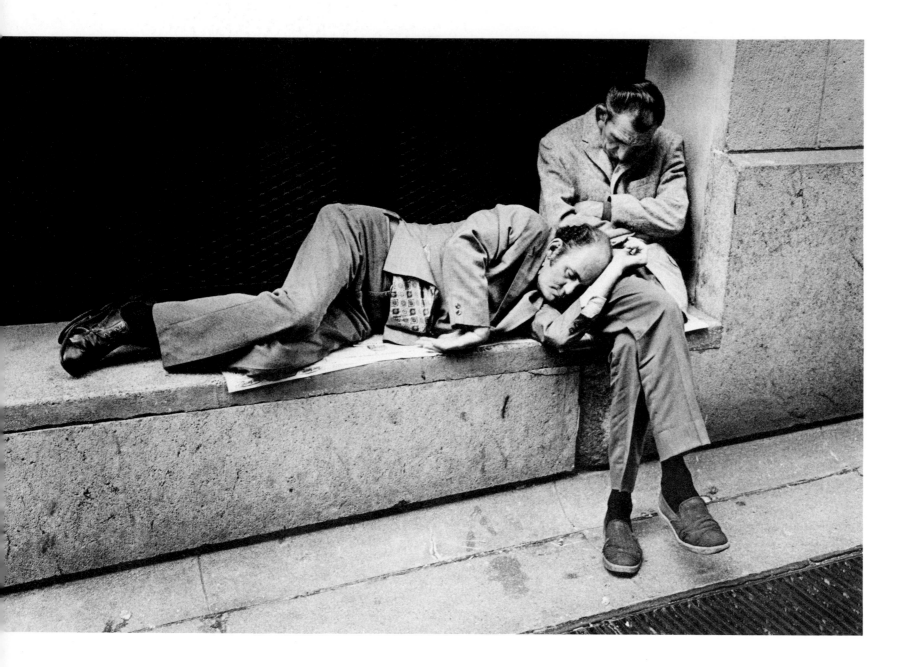

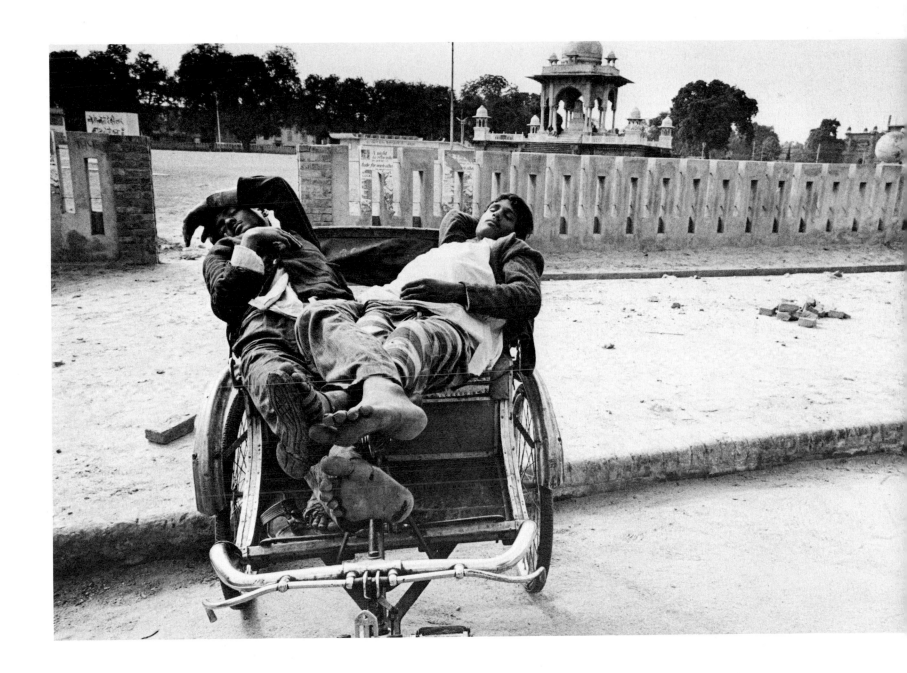

Opposition is true friendship.

WILLIAM BLAKE

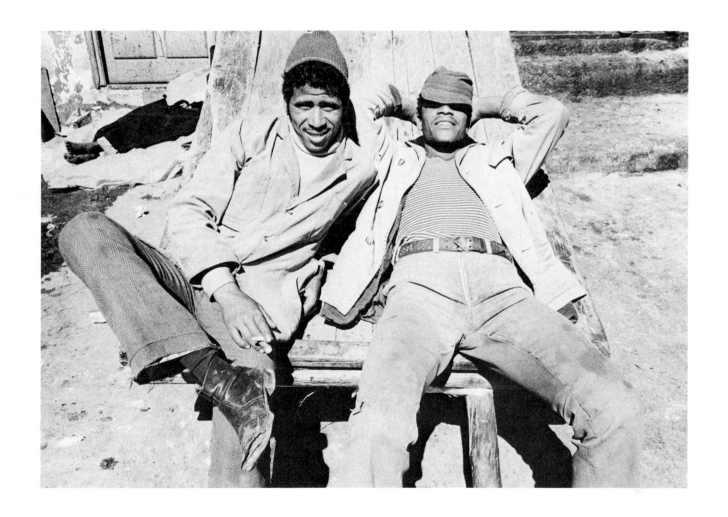

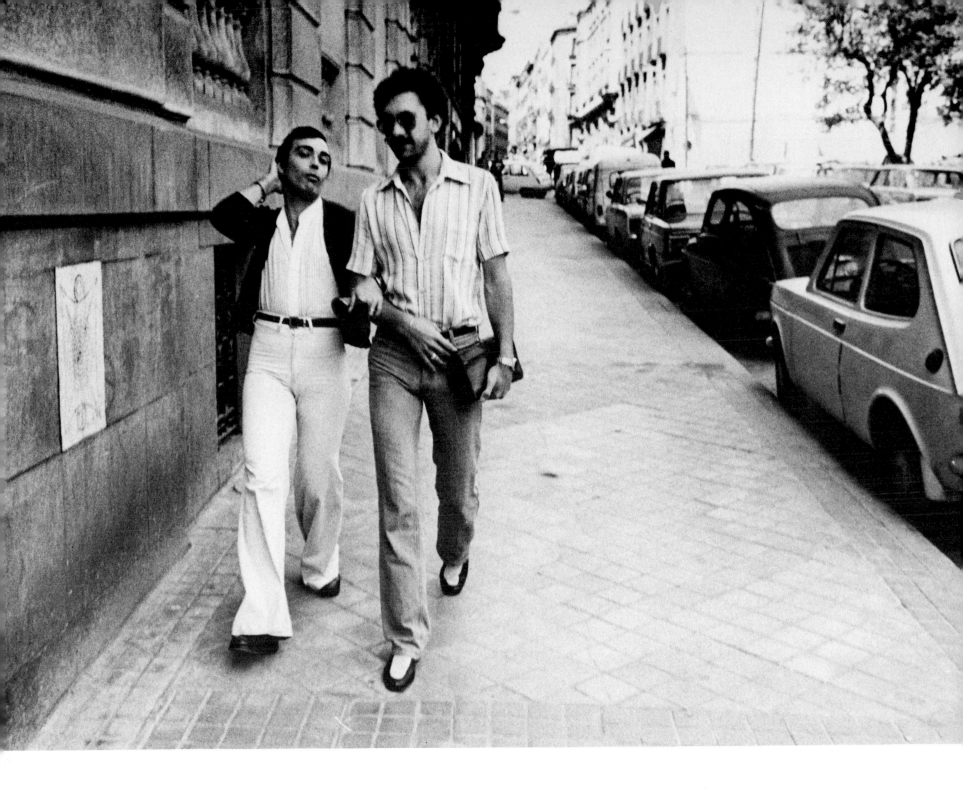

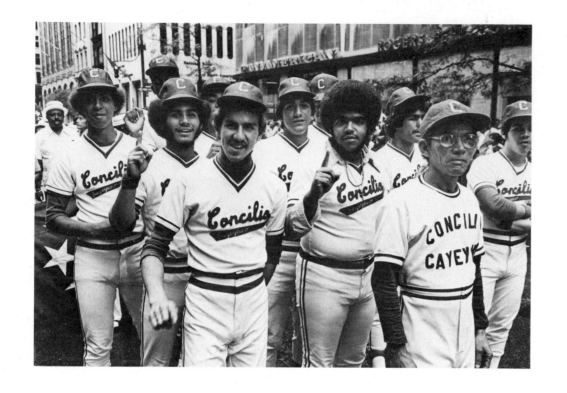

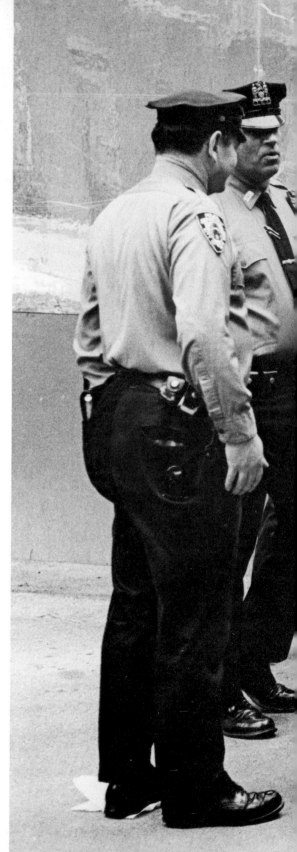

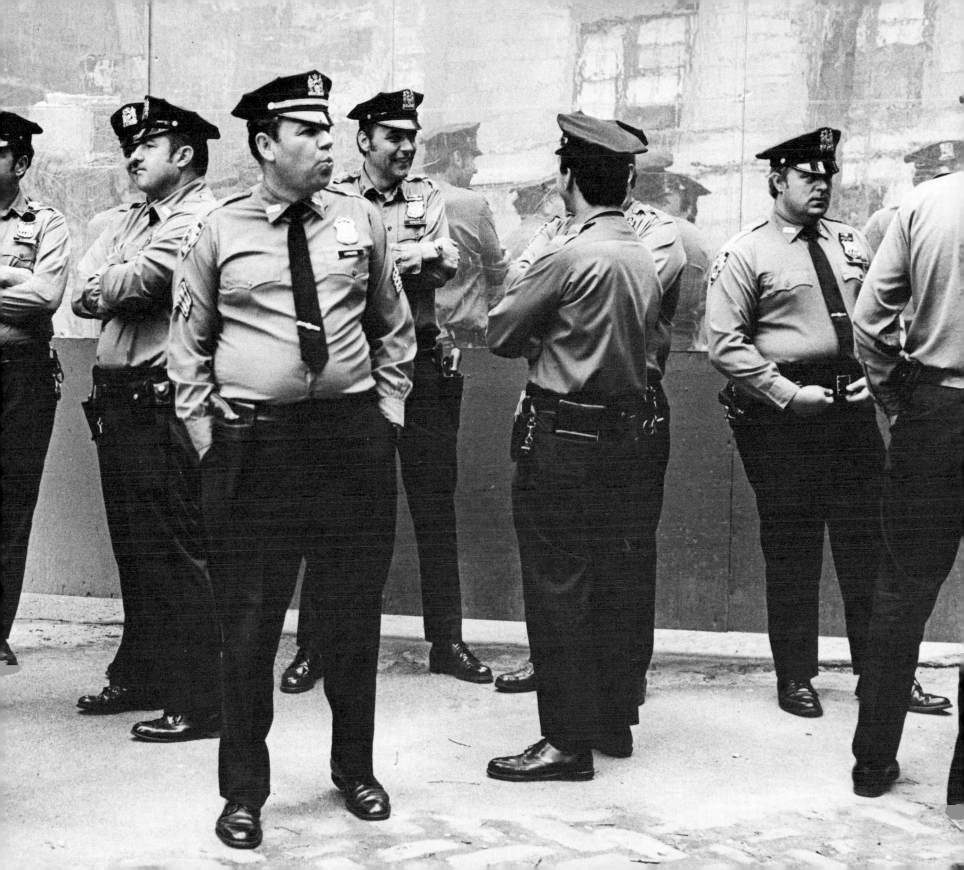

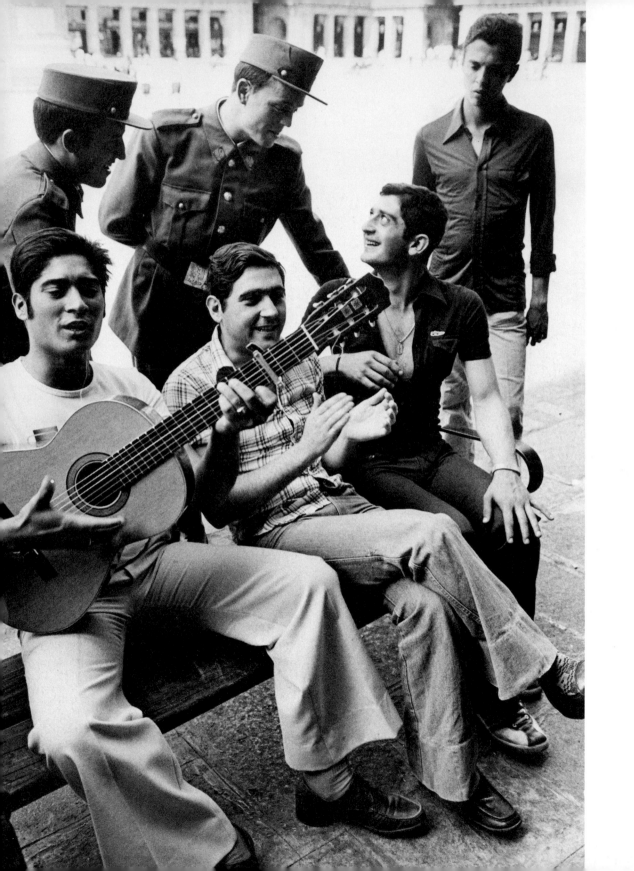
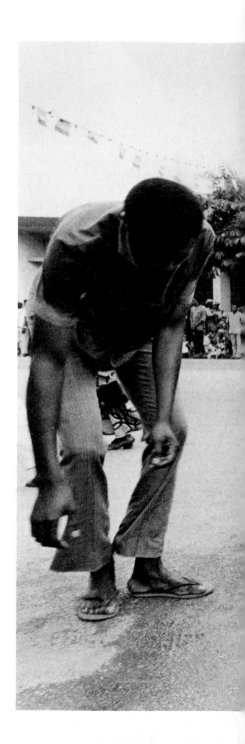

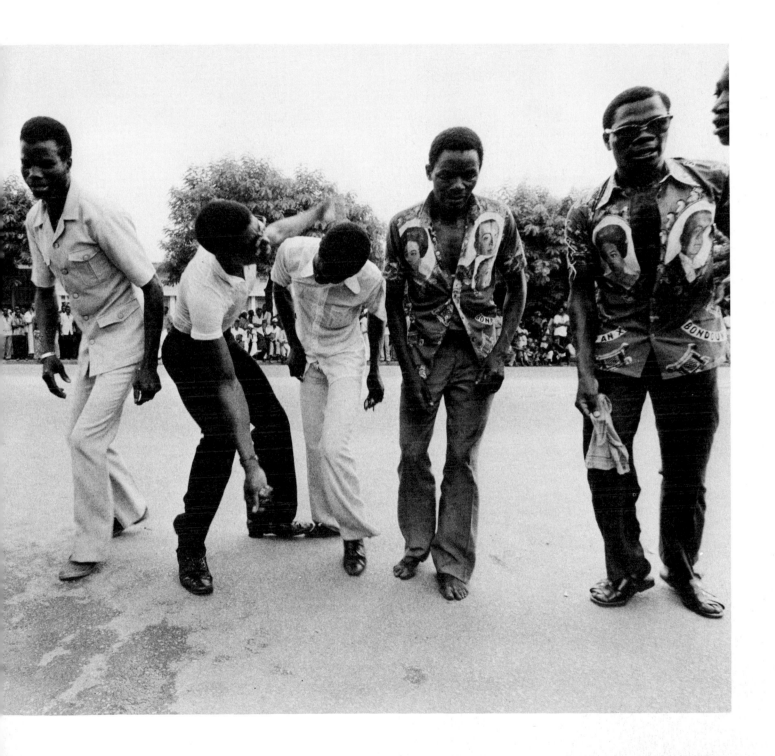

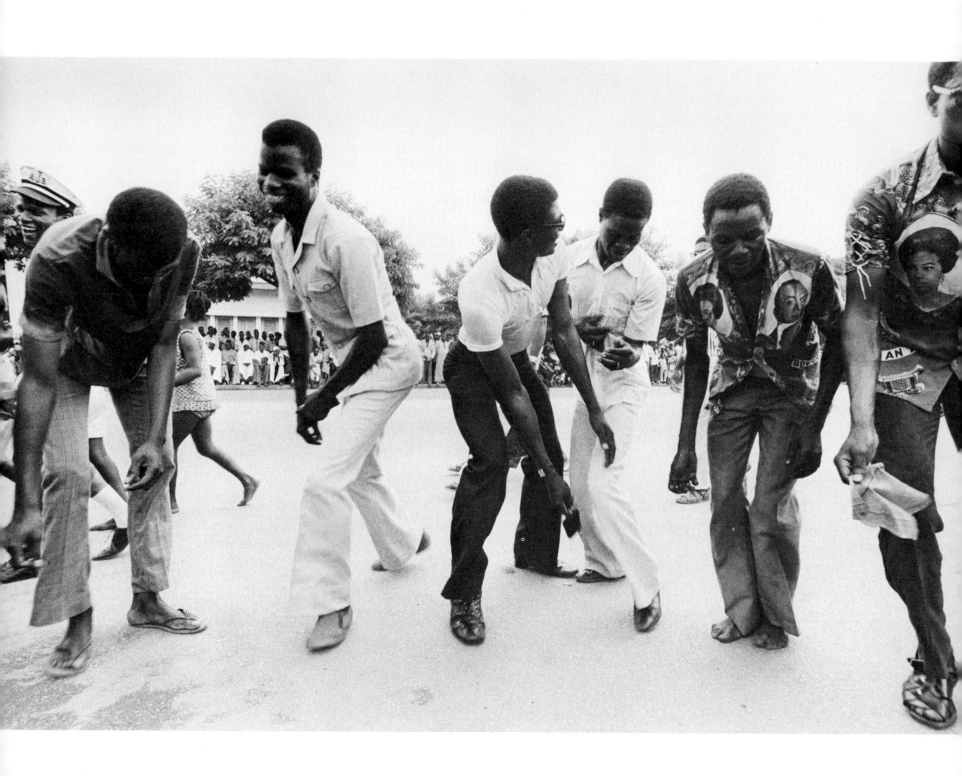

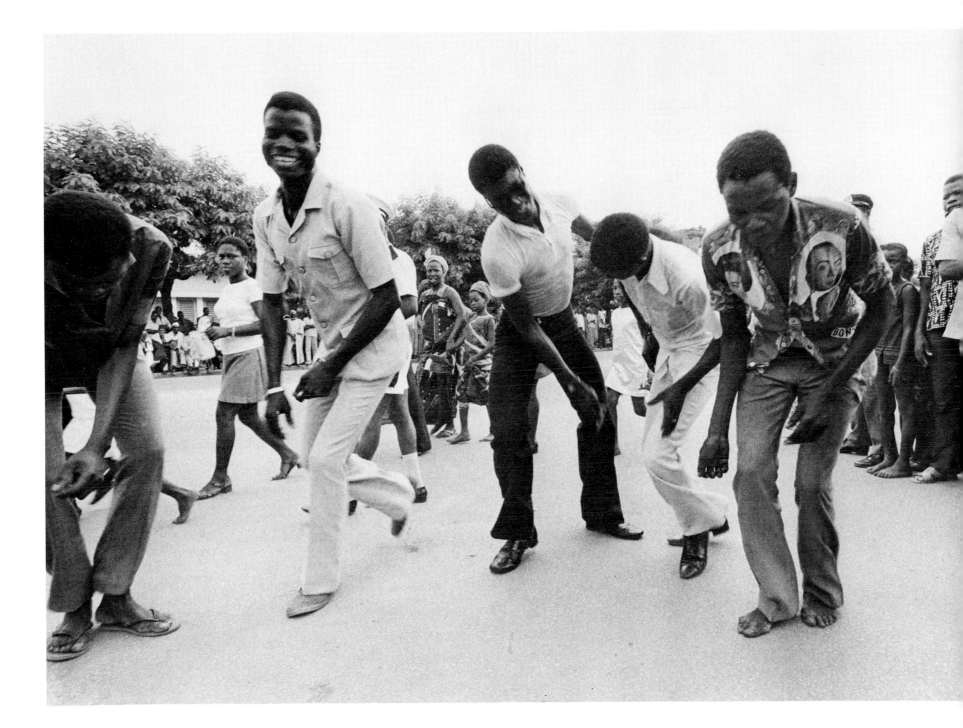

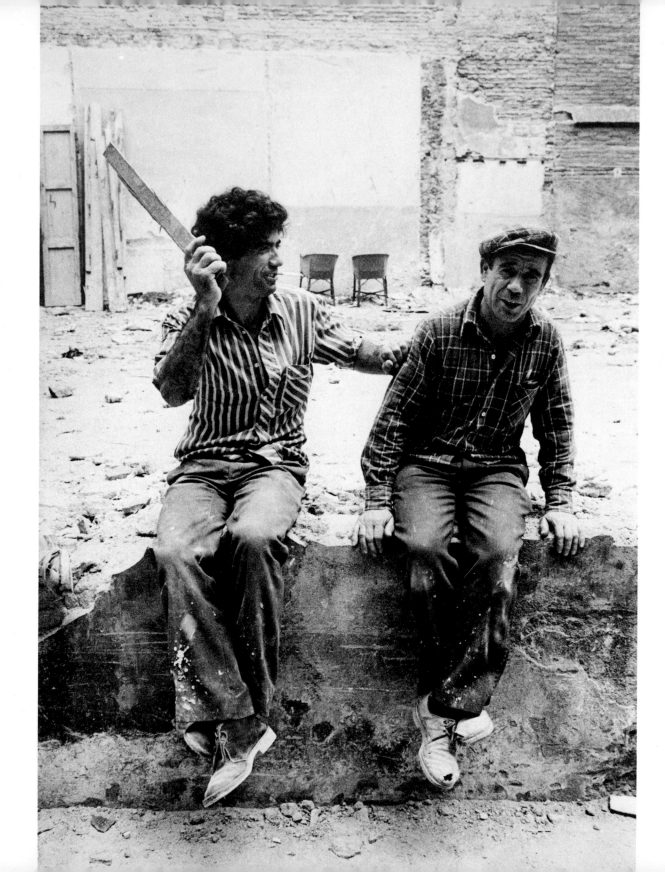

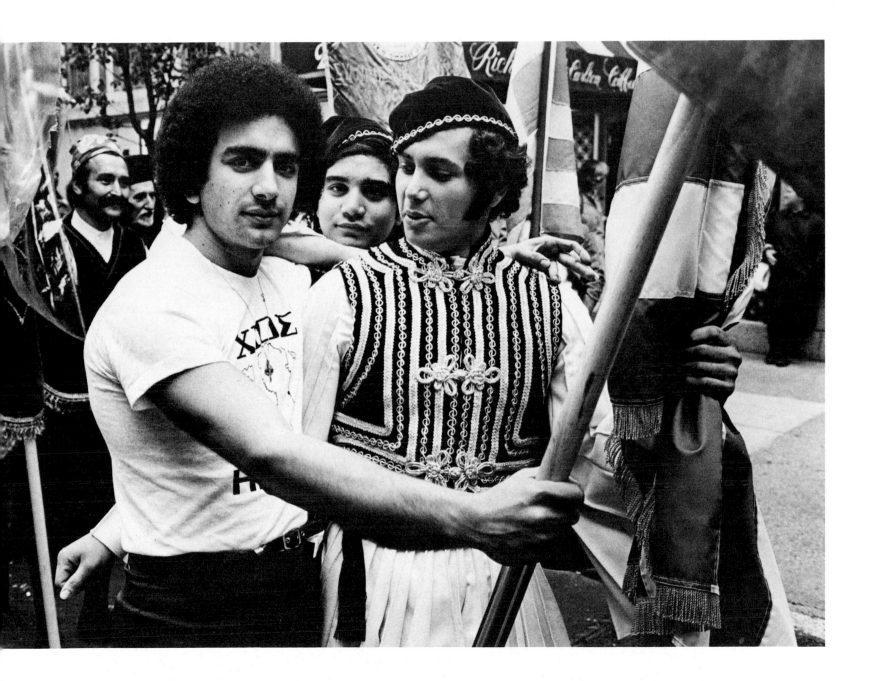

No man is useless while he has a friend.

ROBERT LOUIS STEVENSON

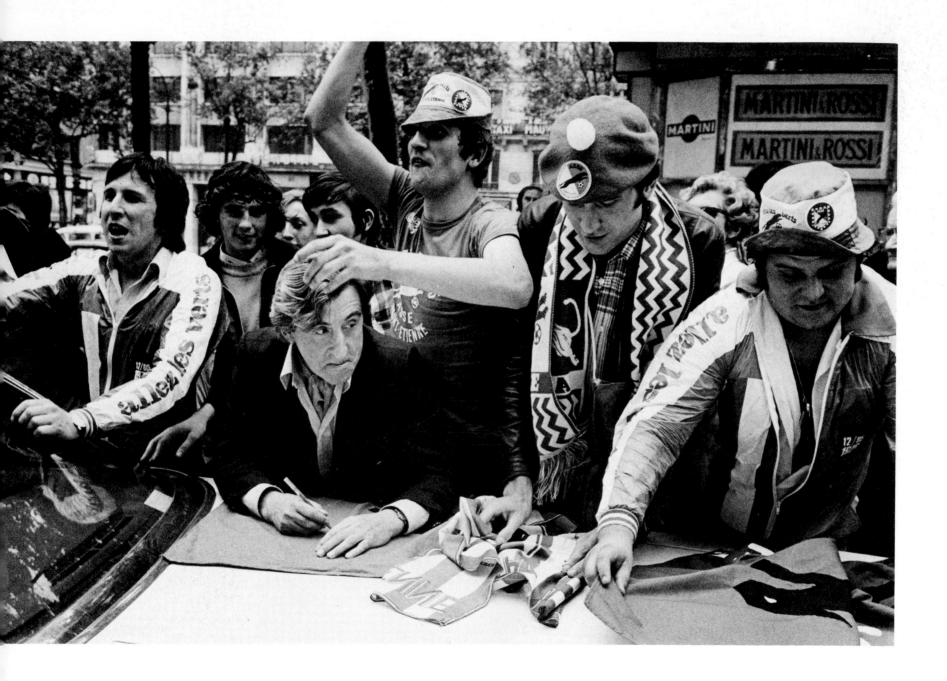

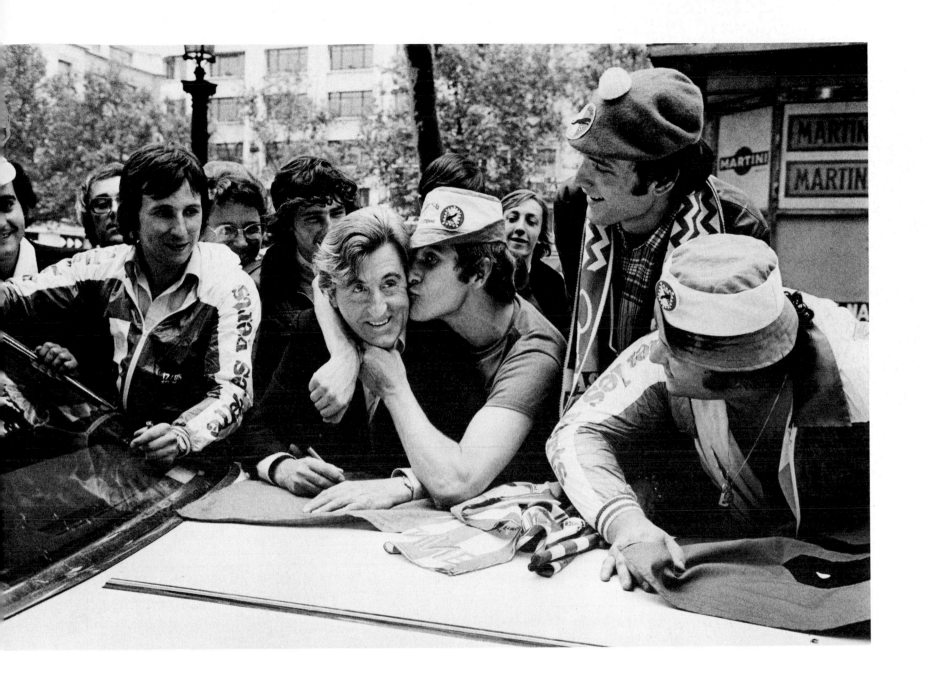

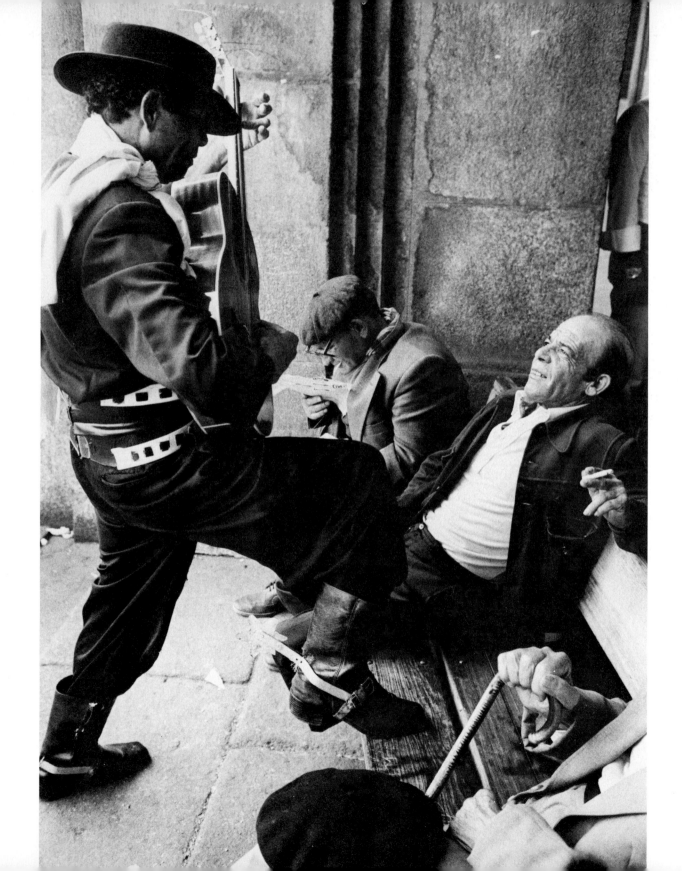

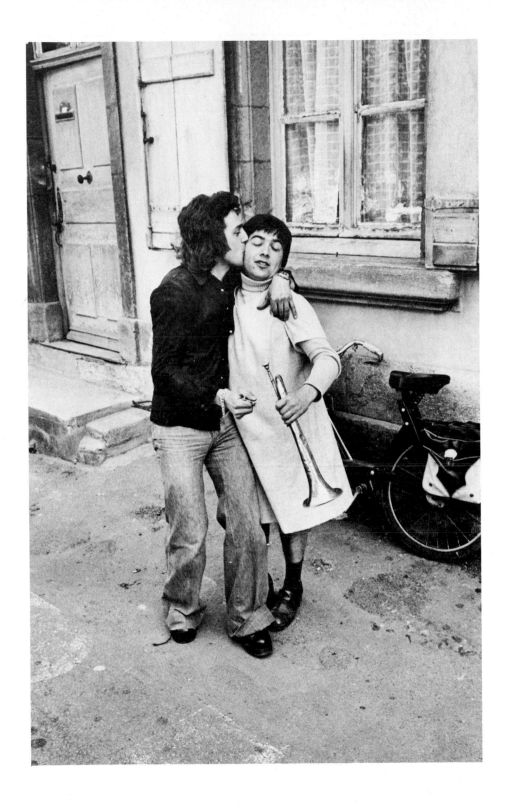

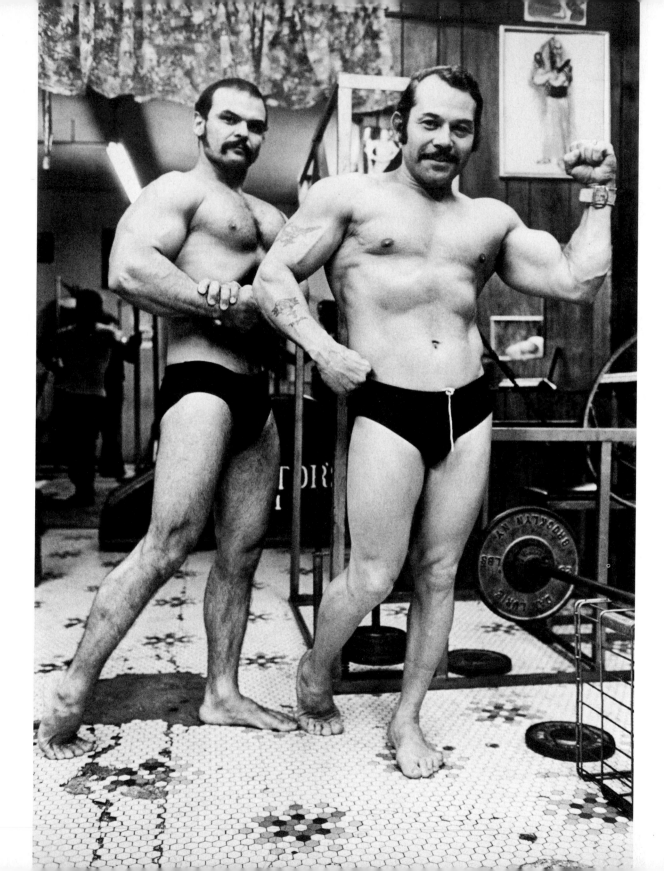

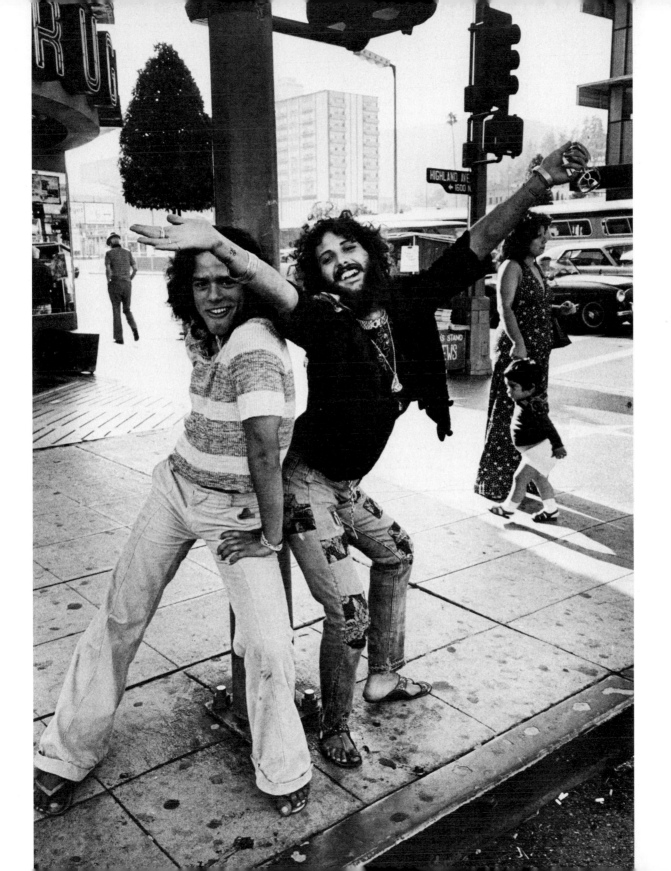

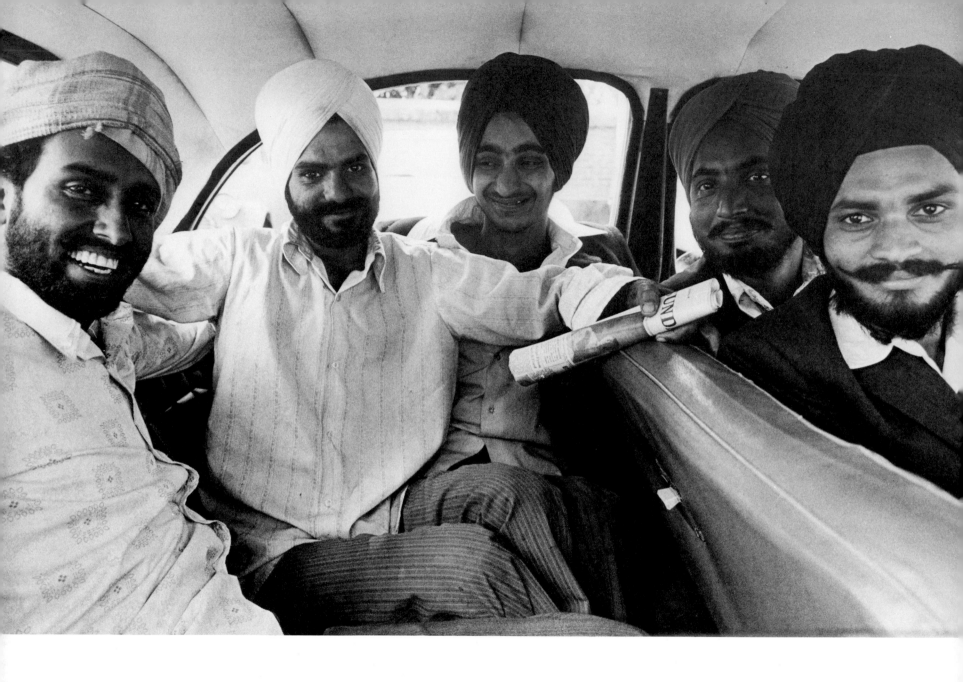

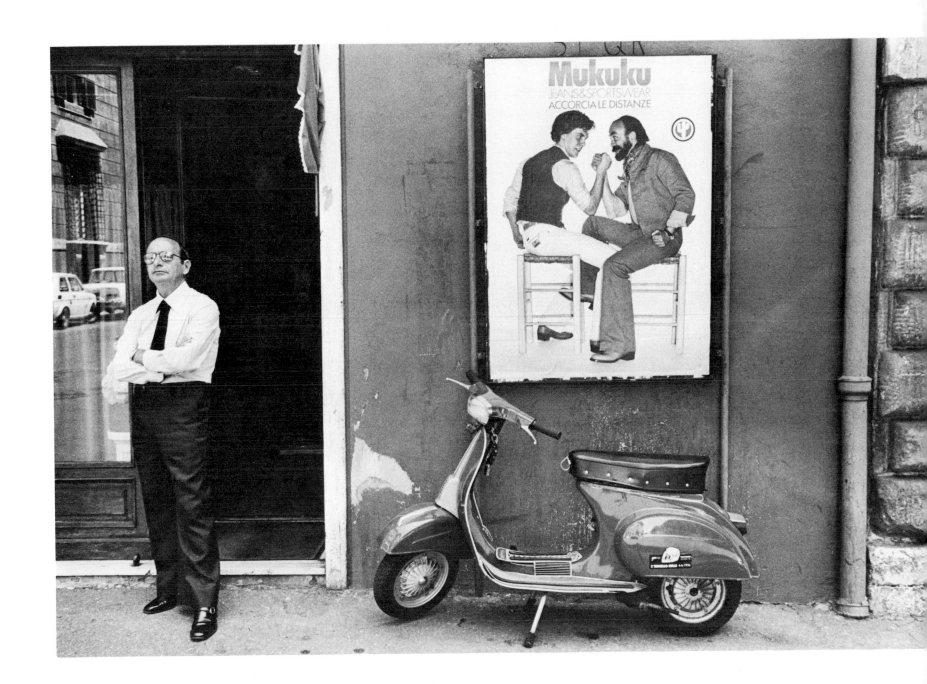

Who seeks a friend without a fault remains without one.
TURKISH PROVERB

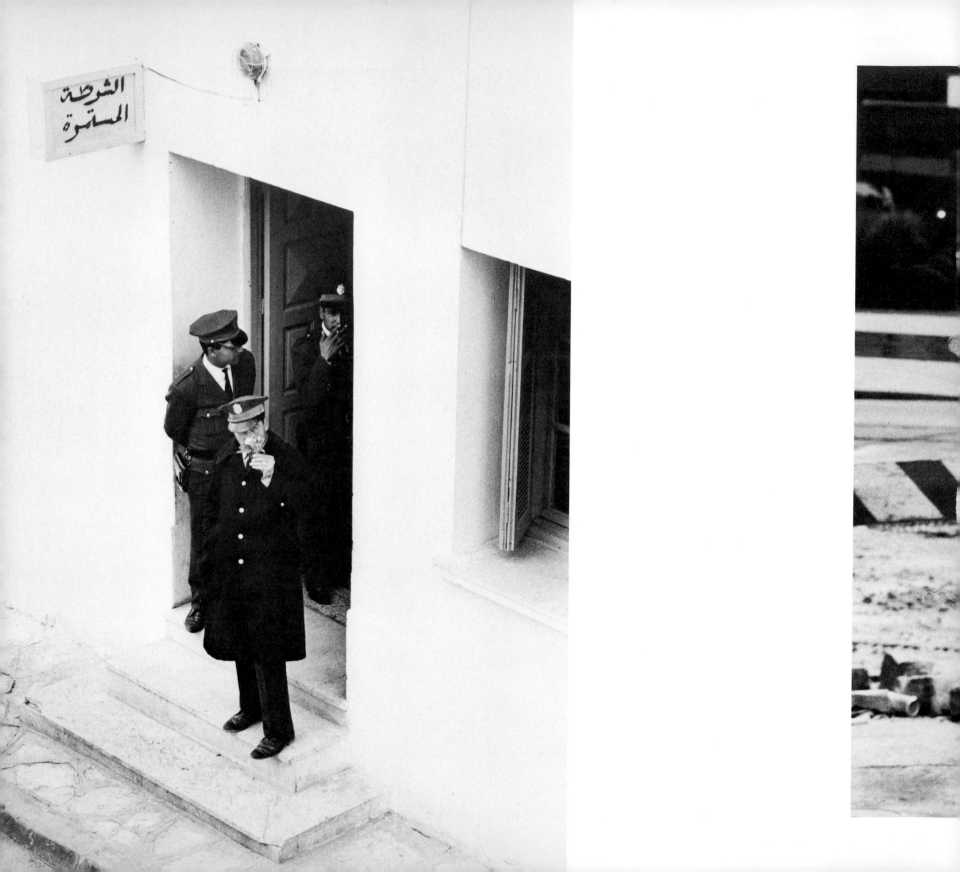

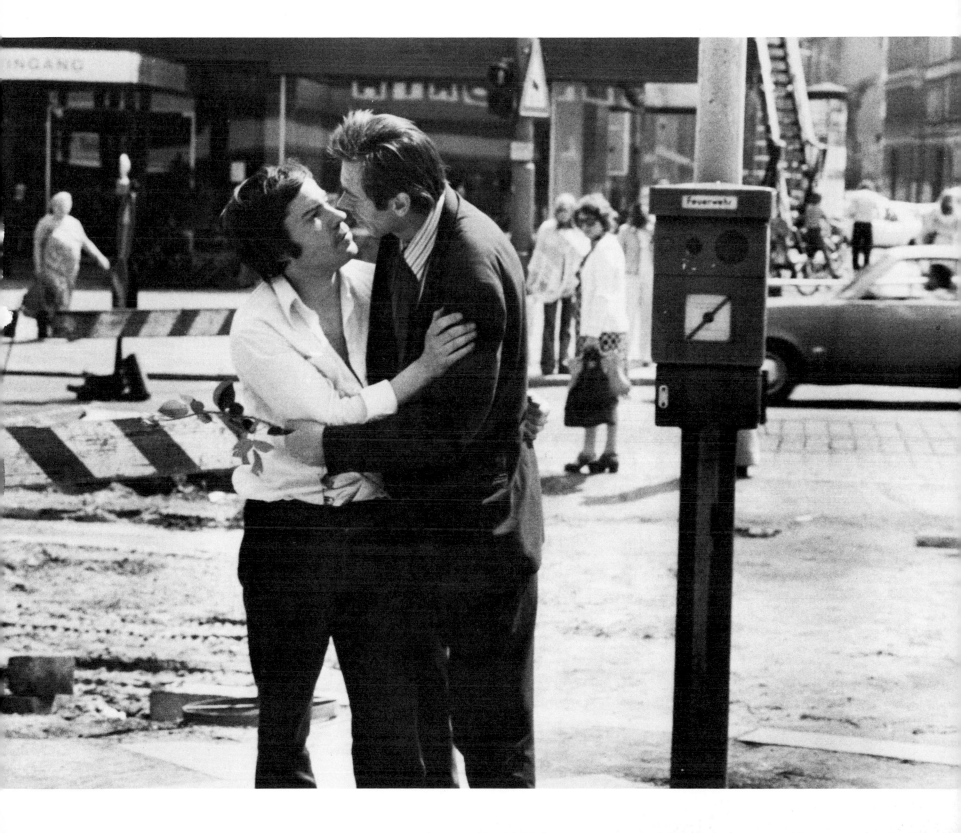

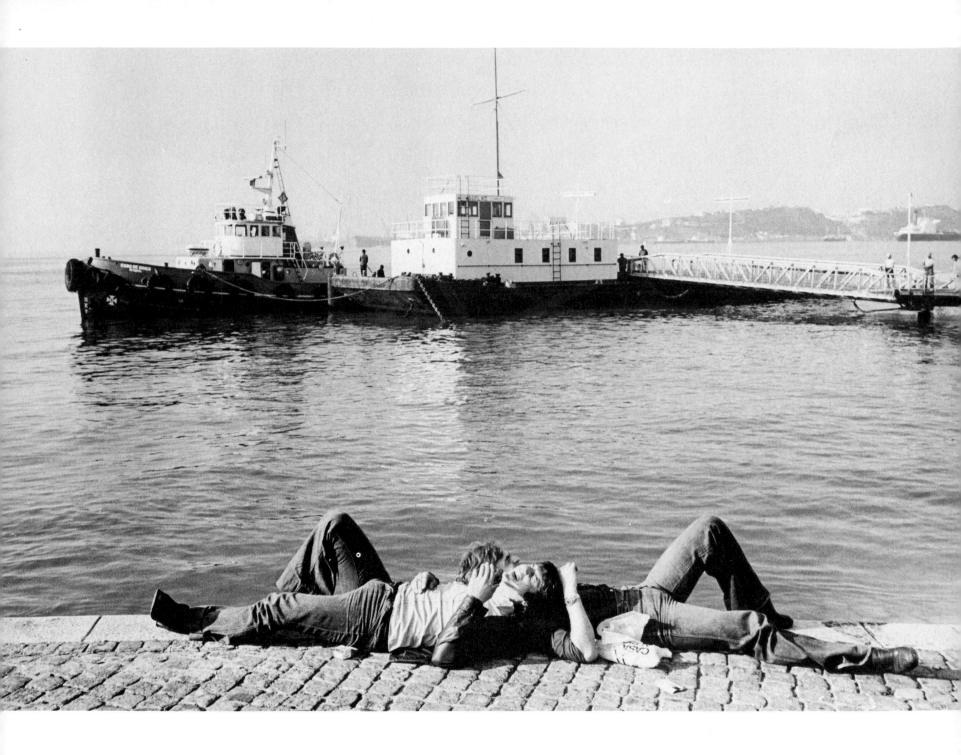

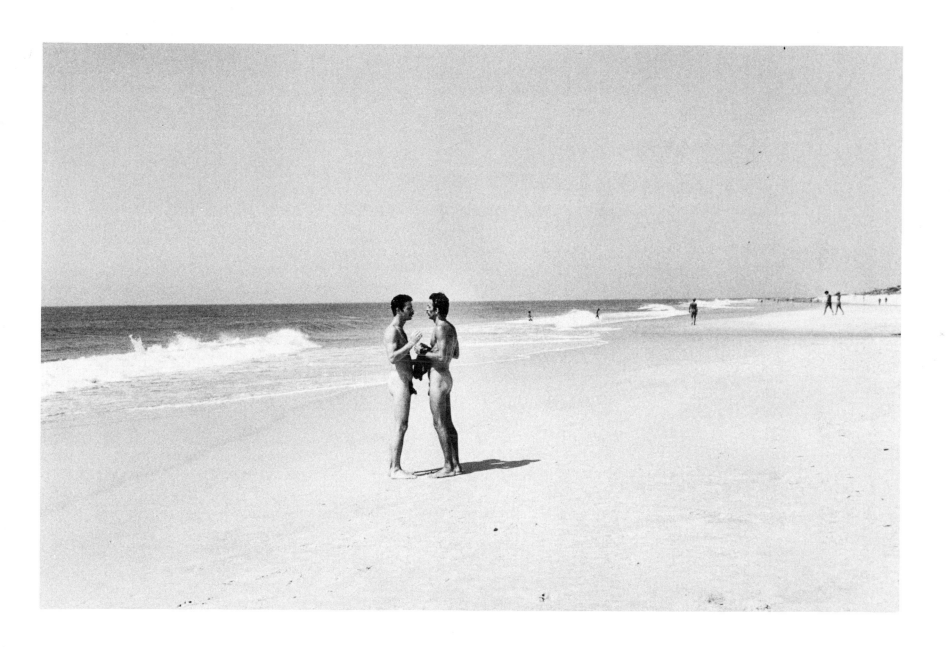

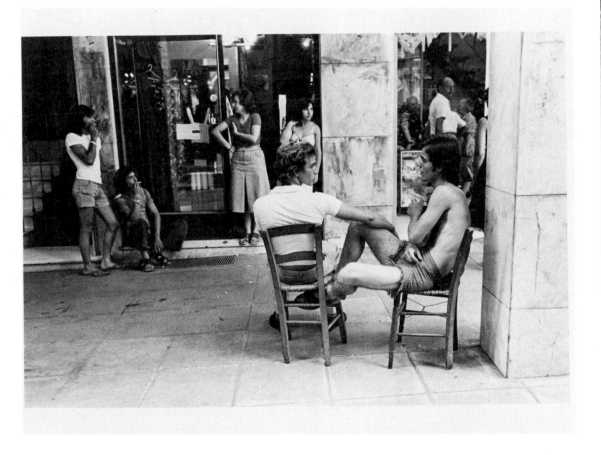

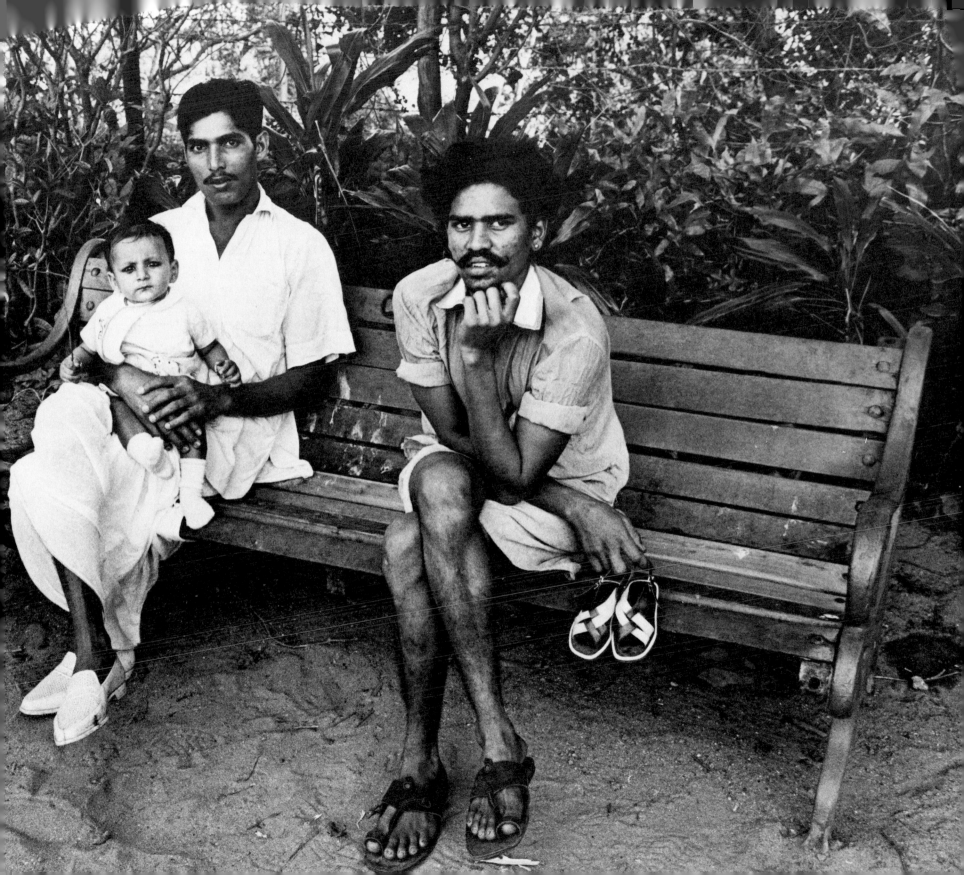

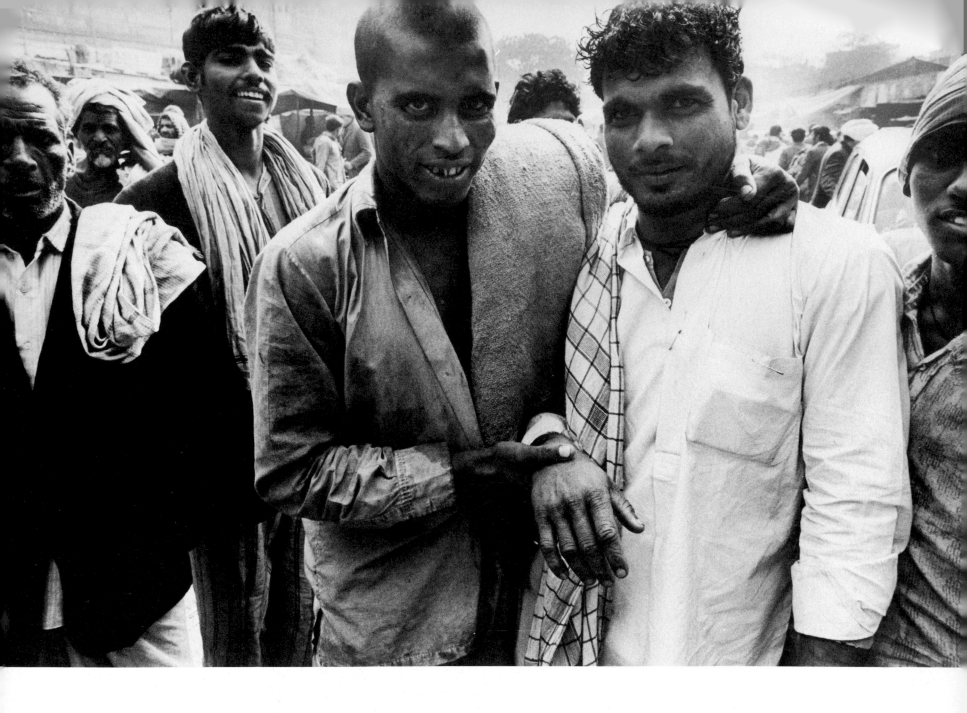

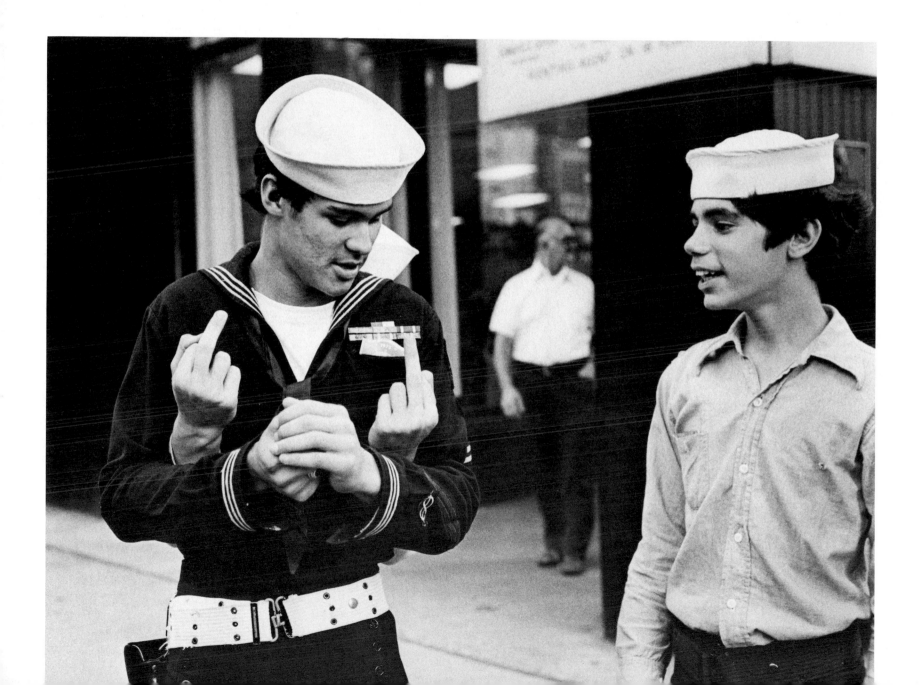

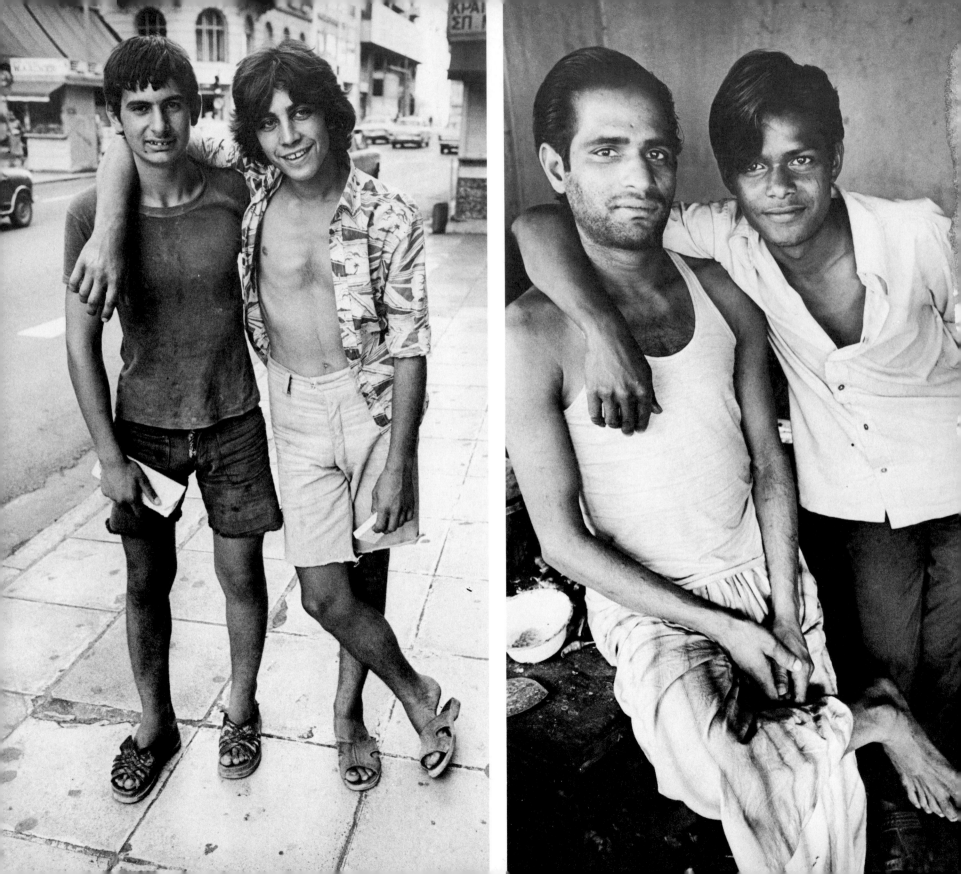

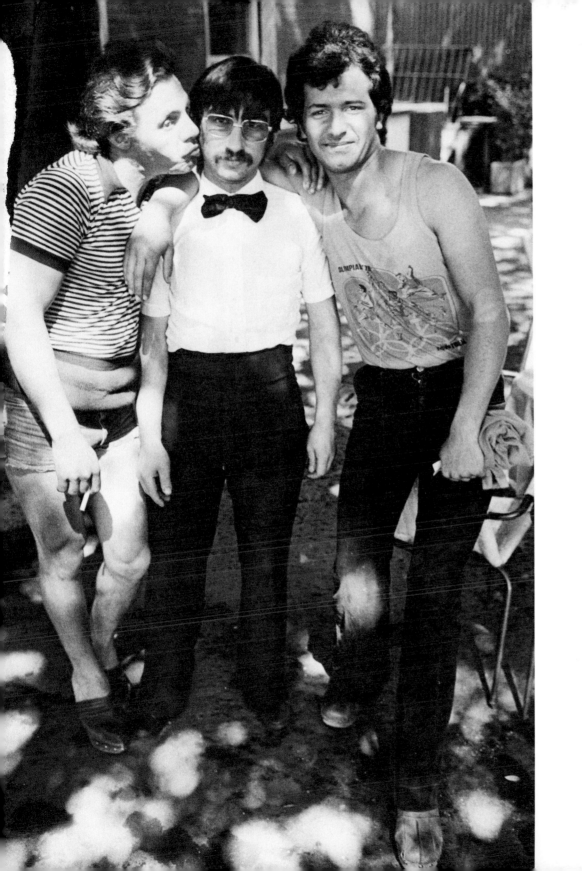
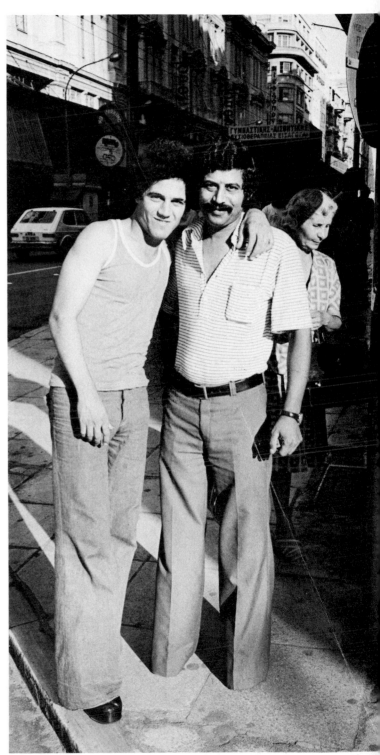

Friendship is unnecessary, like philosophy, like art...
it has no survival value; rather it is one of these things
that gives value to survival.

C. S. LEWIS

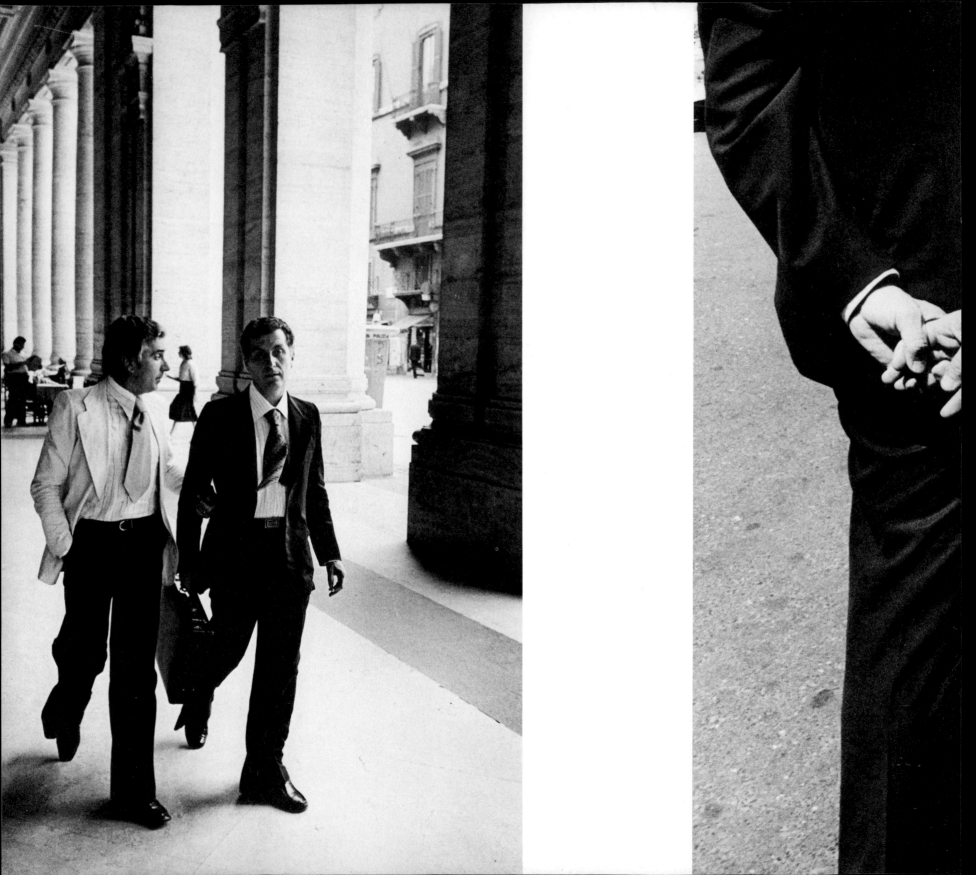

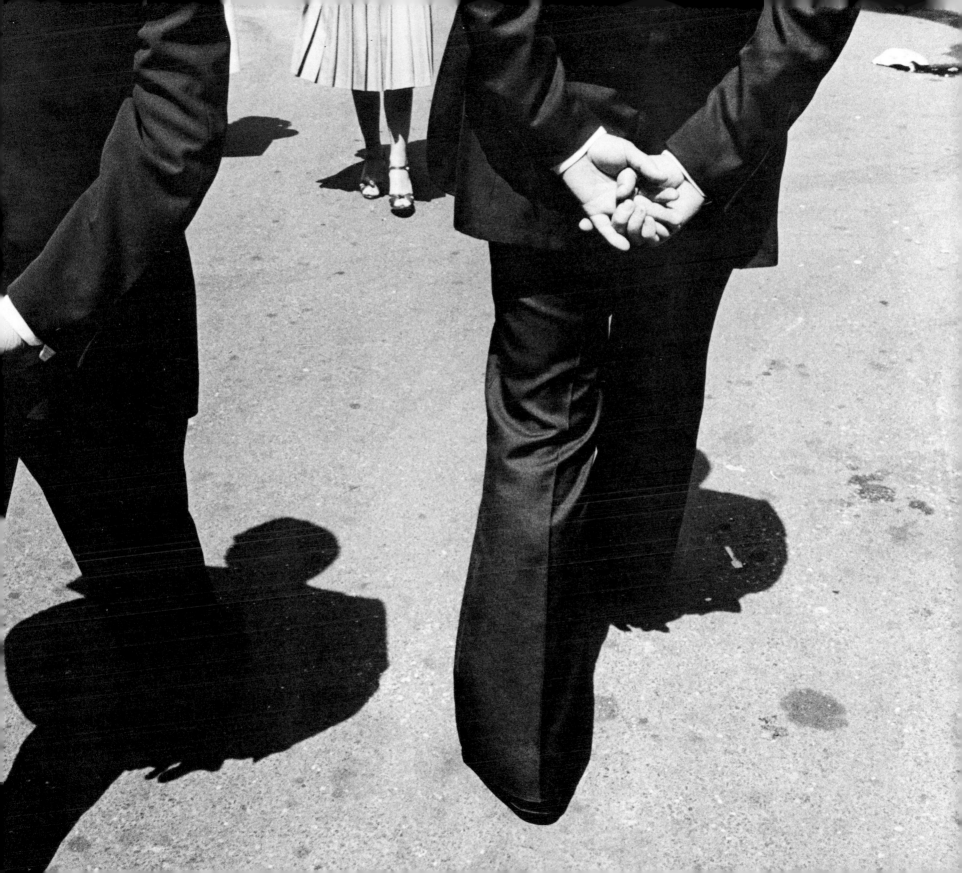

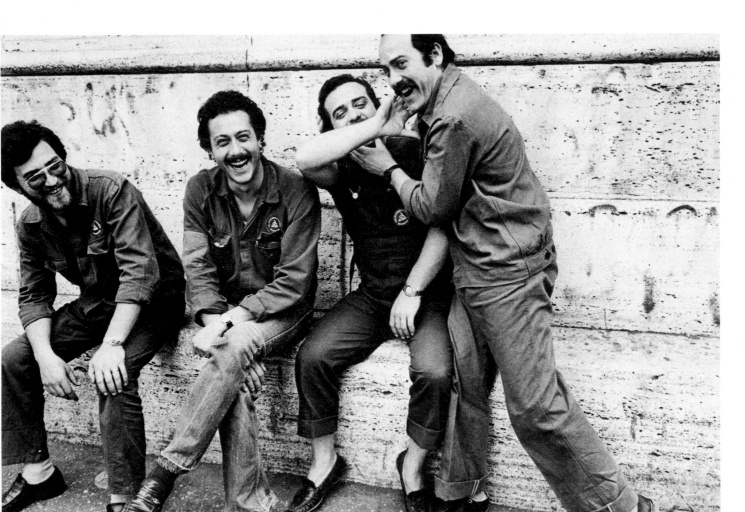

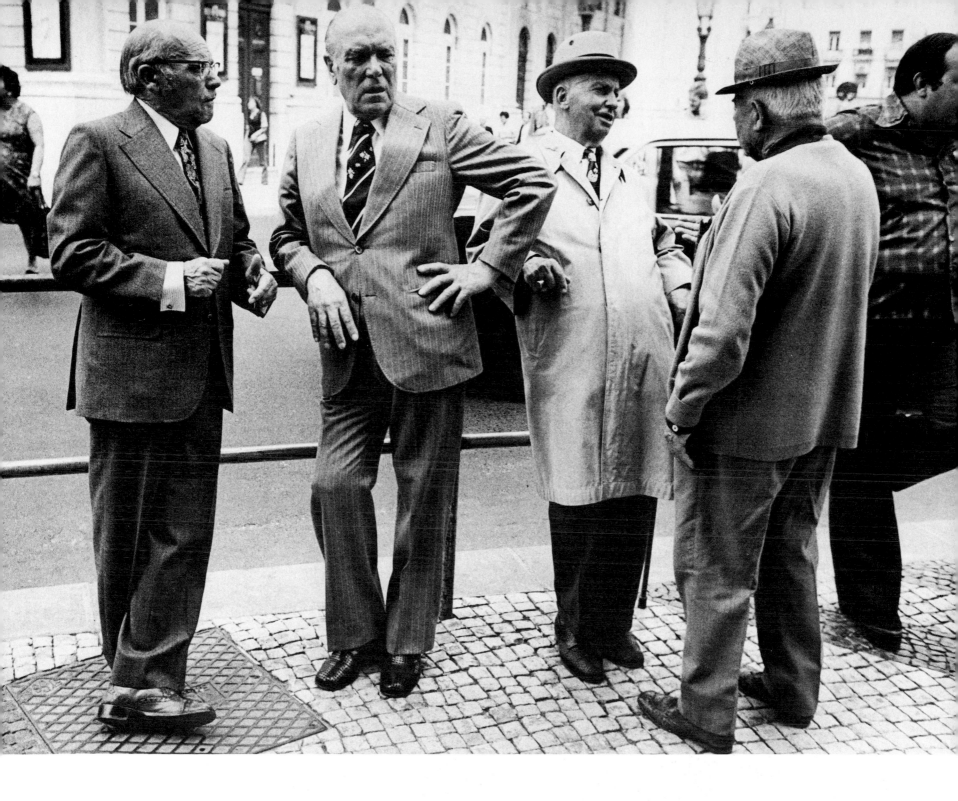

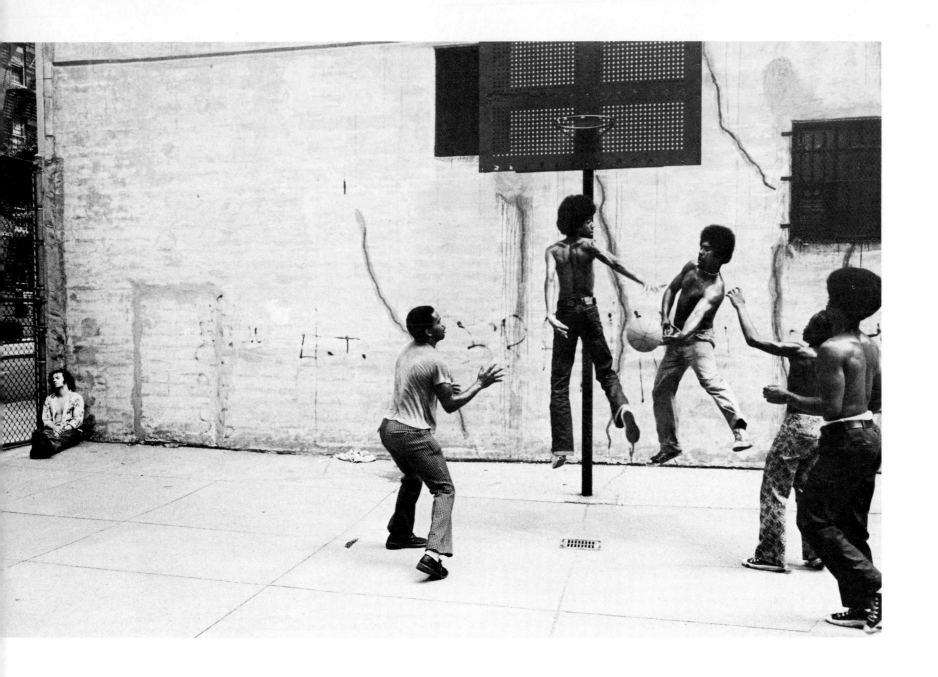

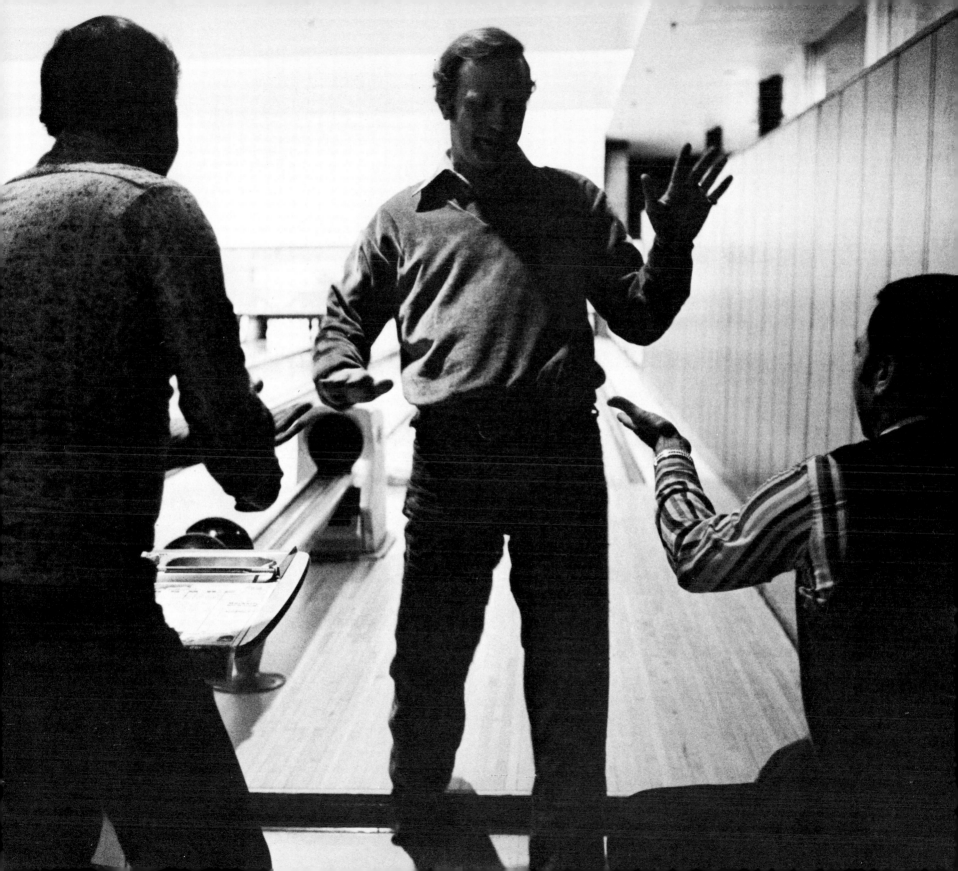

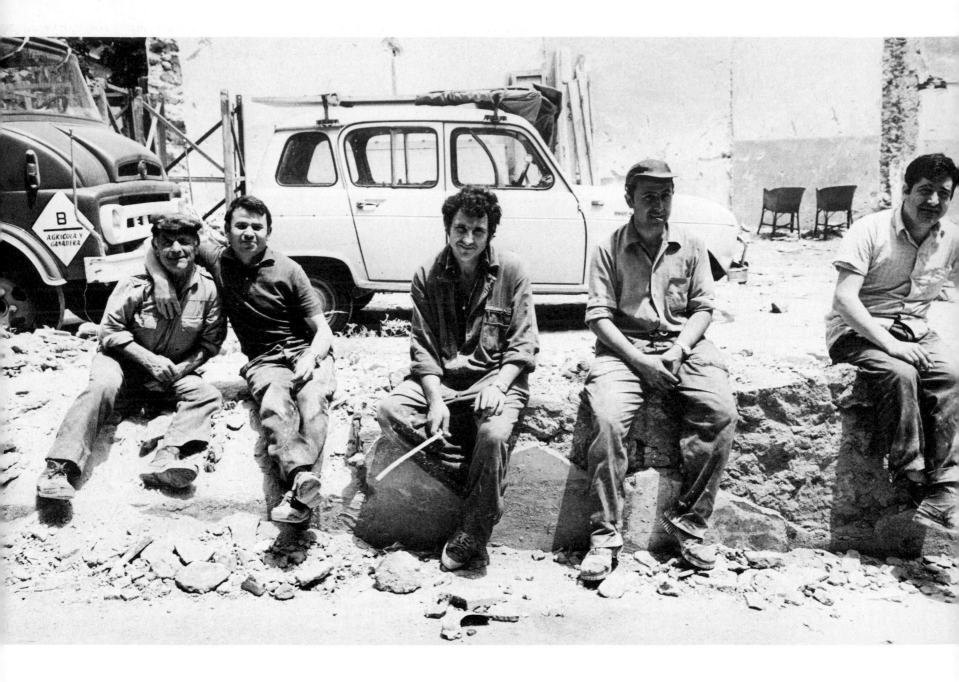

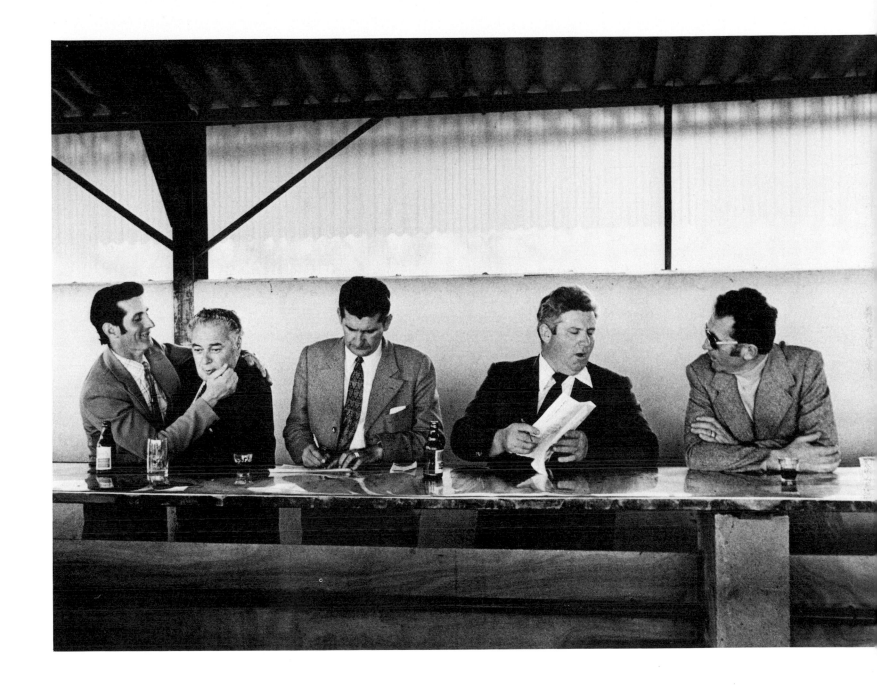

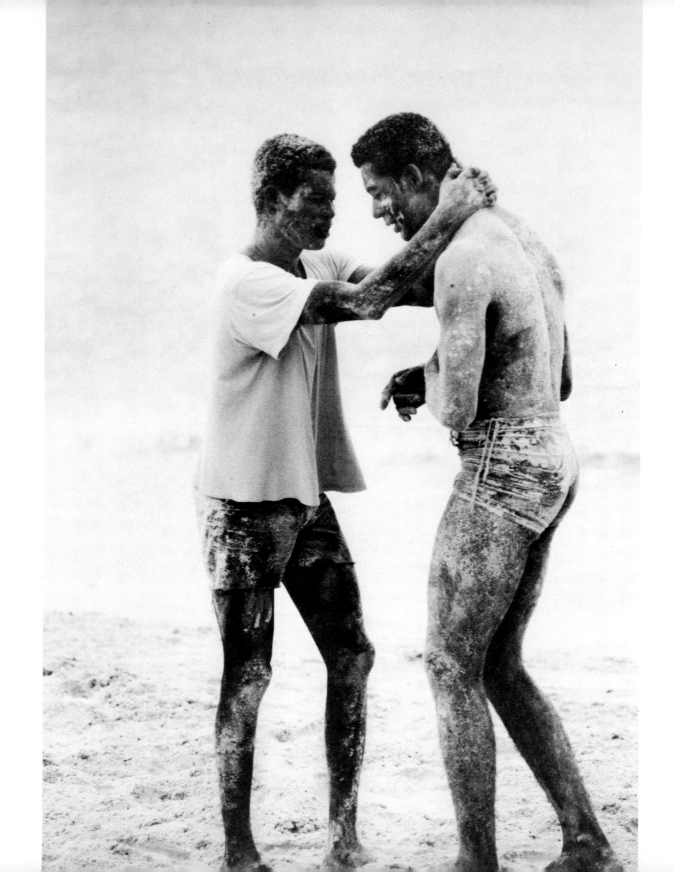

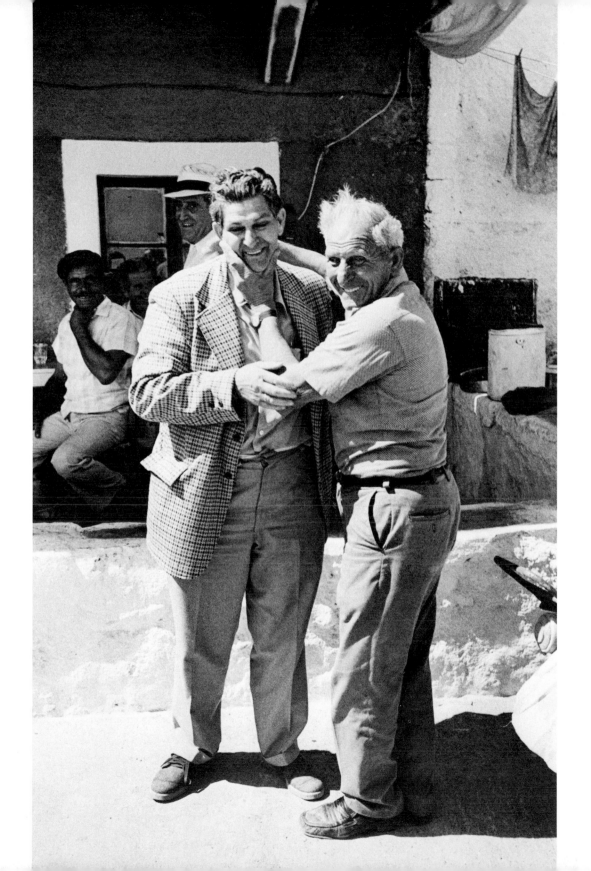

What is a friend?
A single soul dwelling in two bodies.

ARISTOTLE

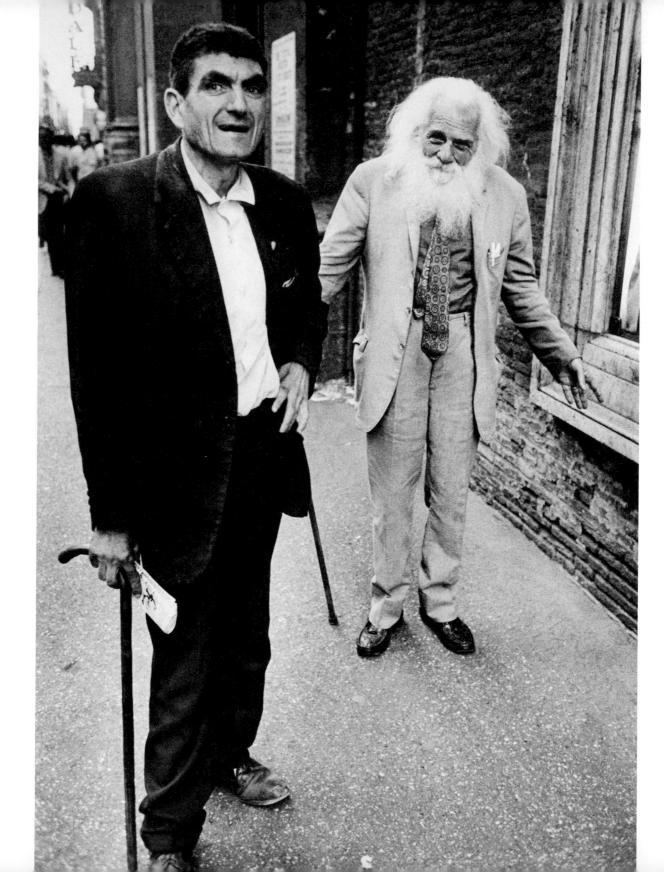

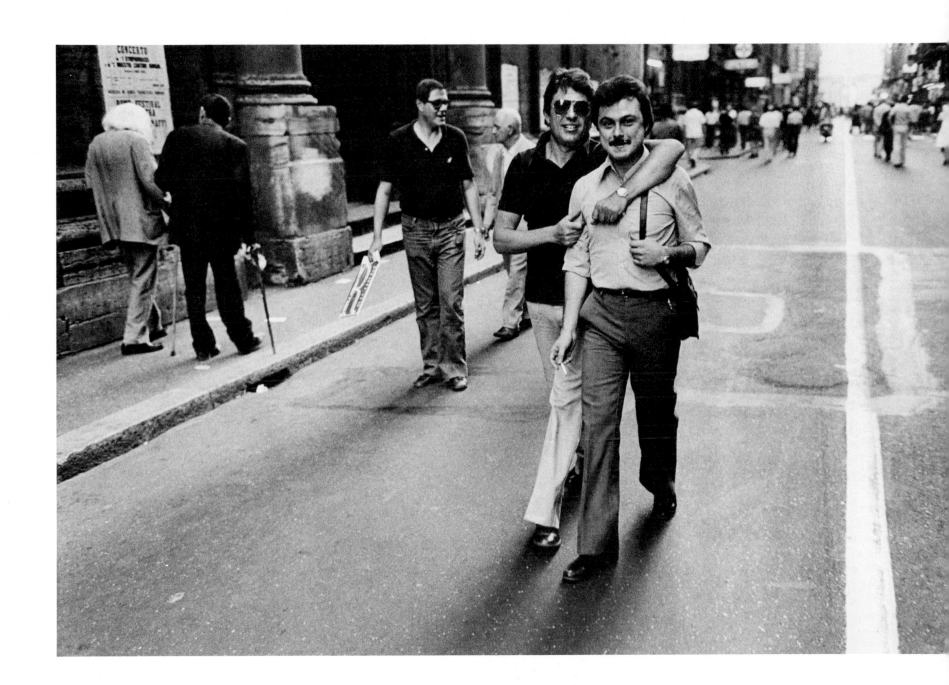

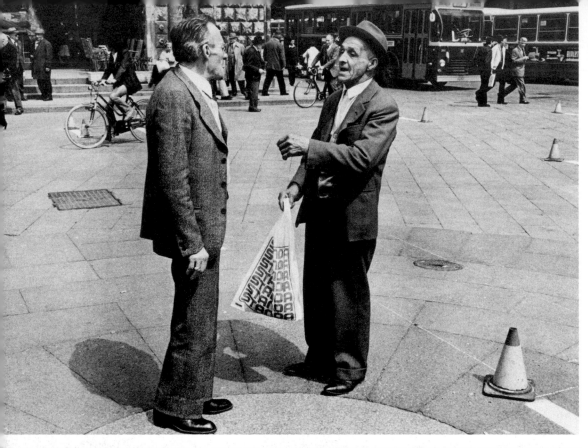
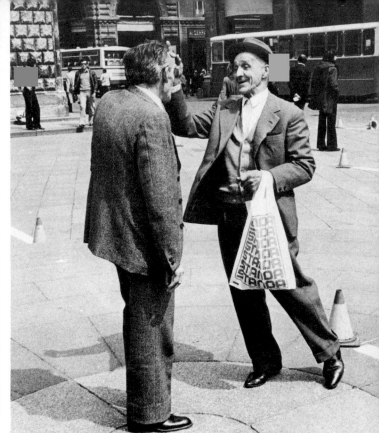
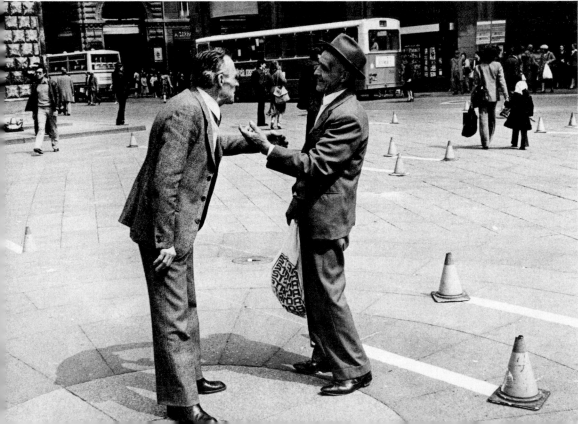
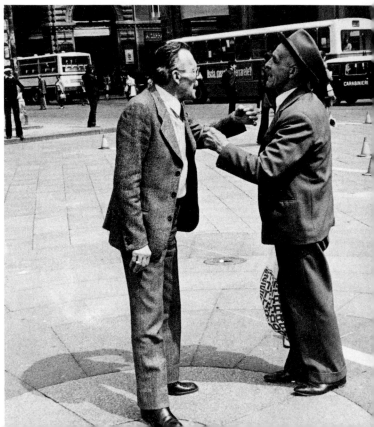

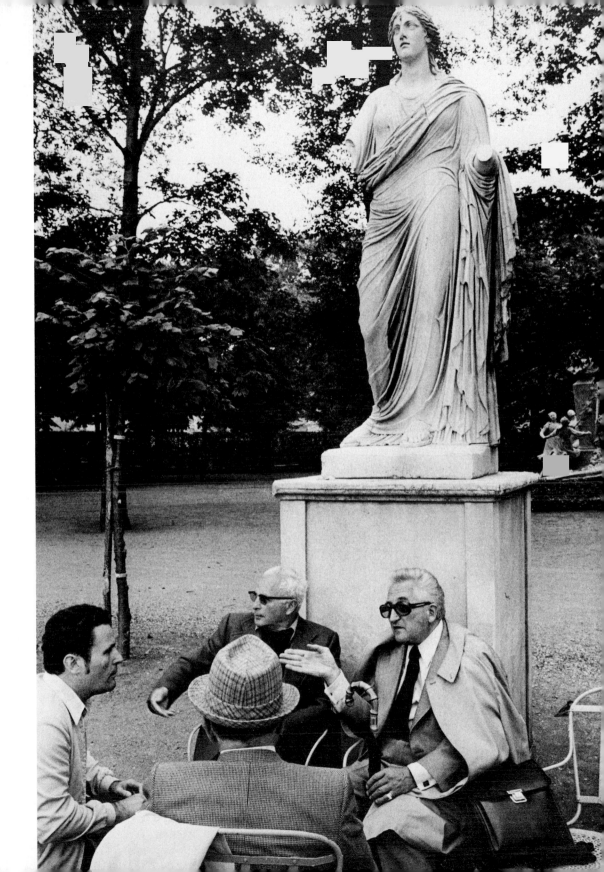

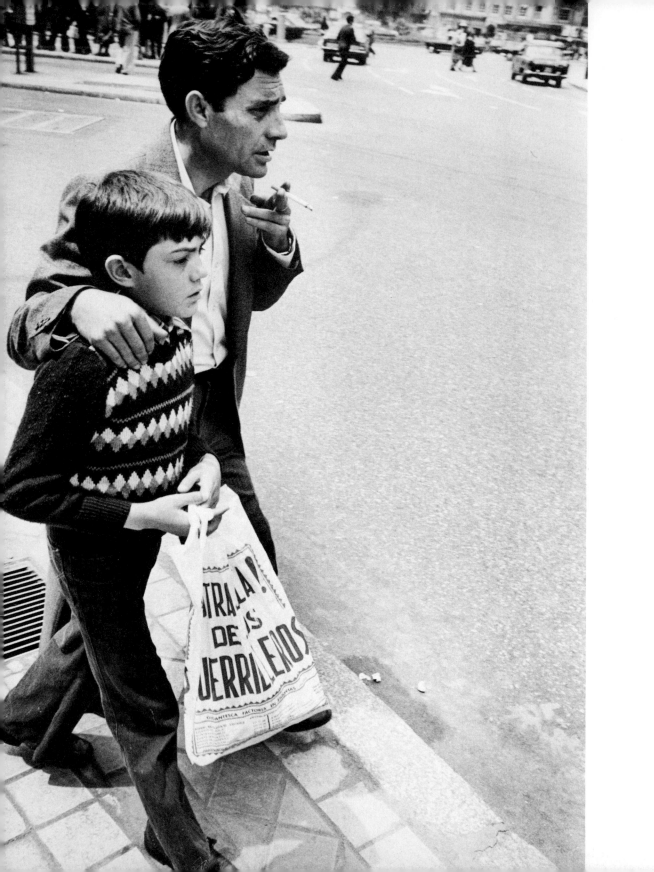

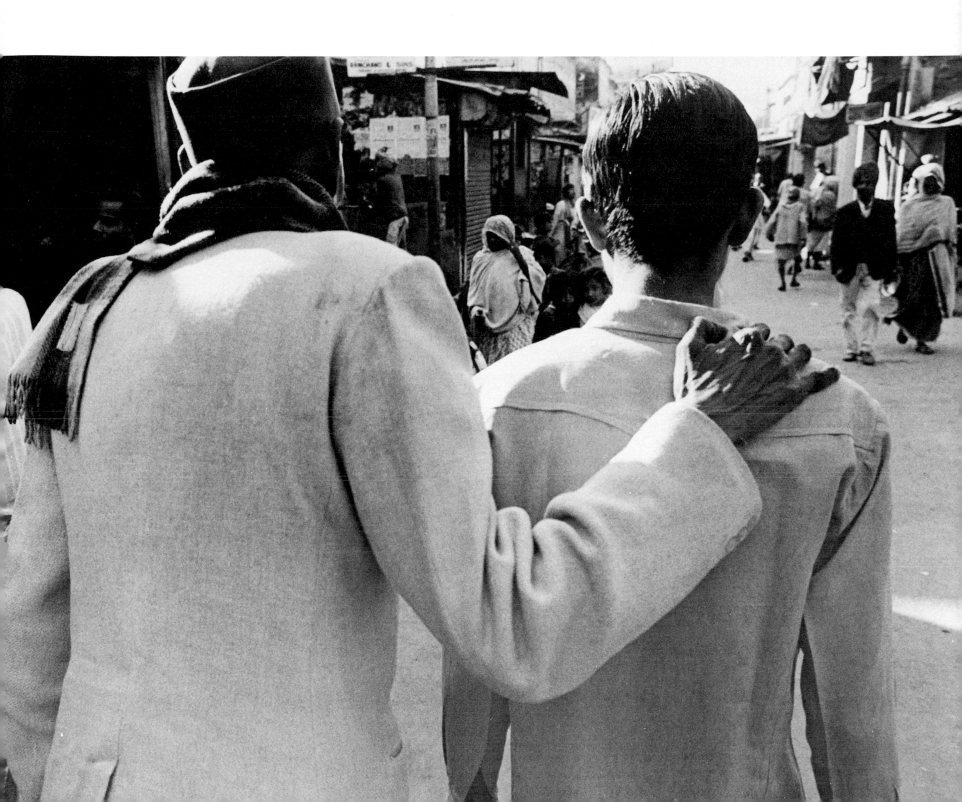

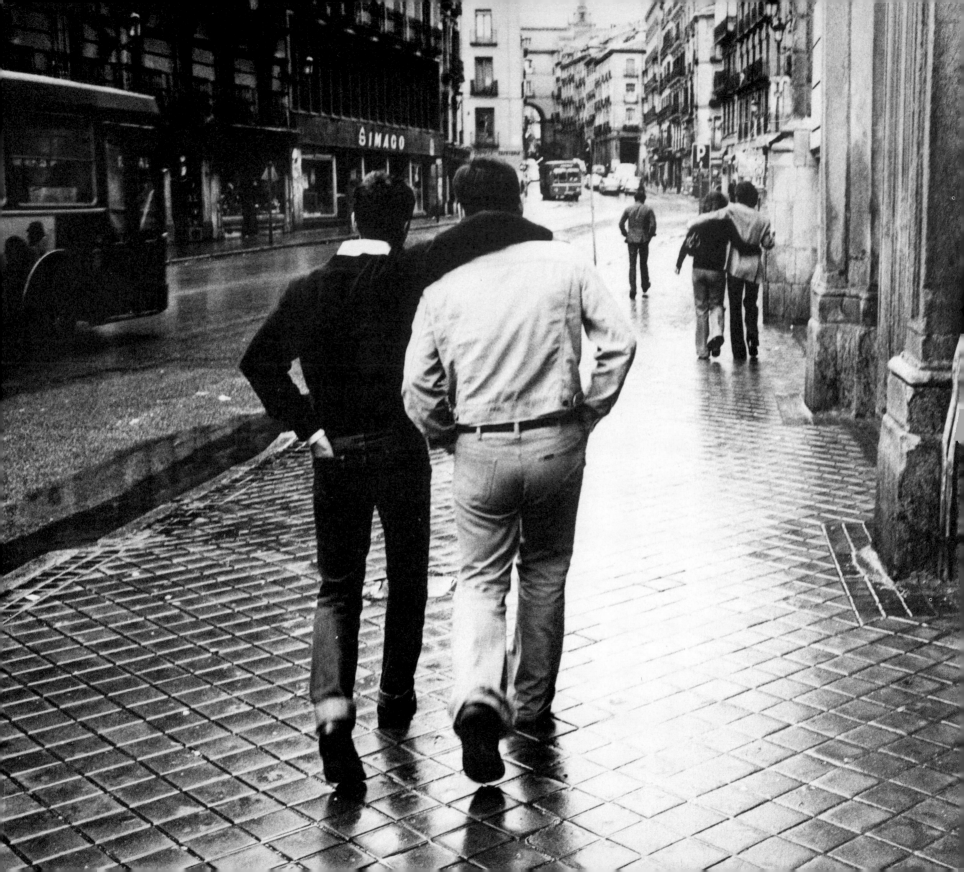

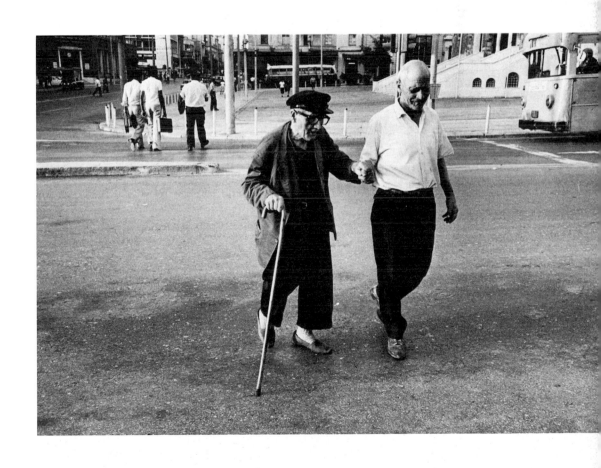

If a friend of mine gave a feast, and did not invite me to it, I should not mind a bit. But if a friend of mine had a sorrow and refused to allow me to share it, I should feel it most bitterly. If he shut the doors of the house of mourning against me, I would move back again and again and beg to be admitted so that I might share in what I was entitled to share. If he thought me unworthy, unfit to weep with him, I should feel it as the most poignant humiliation.

OSCAR WILDE

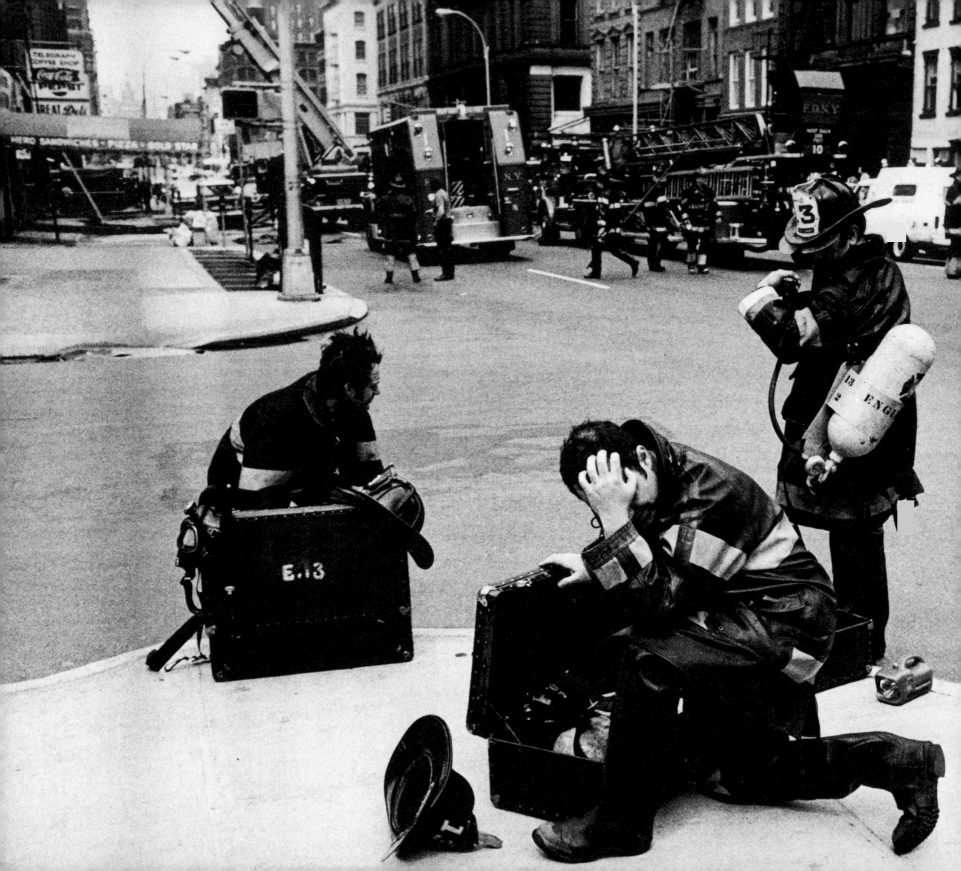

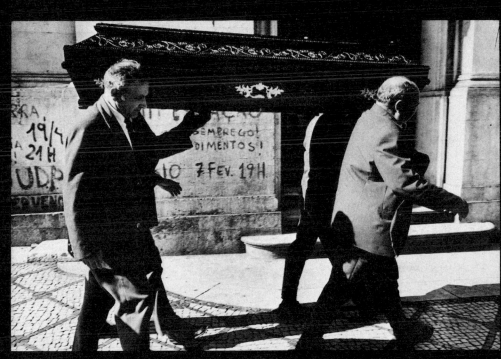

ABOUT THE AUTHOR

Bernard Pierre Wolff was born in France in 1930 and became interested in film, photography and graphic design at a very young age. After completing his studies in Paris, he worked at La Cinémathèque Française as special assistant to its director, the late Henri Langlois.

Wolff came to the United States in 1958 as a graphic designer, but subsequently turned to photography. During the past fifteen years he has undertaken numerous photographic assignments in Africa, Asia, Europe and Latin America for United Nations agencies and other international organizations. Many photographs from these areas are included in <u>Friends and Friends of Friends.</u>

Wolff's pictures have been published in the <u>New York Times,</u> the <u>Herald Tribune,</u> <u>Saturday Review,</u> <u>After Dark,</u> <u>Camera 35,</u> <u>Modern Photography,</u> the French magazine <u>Zoom,</u> the Italian magazine <u>Progresso Fotografico</u> and the <u>British Journal of Photography Annual 1977.</u> His photographs were exhibited in Paris at the Gallerie of the Bibliothèque Nationale in 1975, and he has had four one-man exhibitions at New York galleries since 1974. An exhibit of forty photographs from India has been traveling to universities and galleries throughout the United States, under the auspices of Apeiron Workshops, for the past three years.